Jean Pierre Lefebvre

vidéaste

Jean Pierre

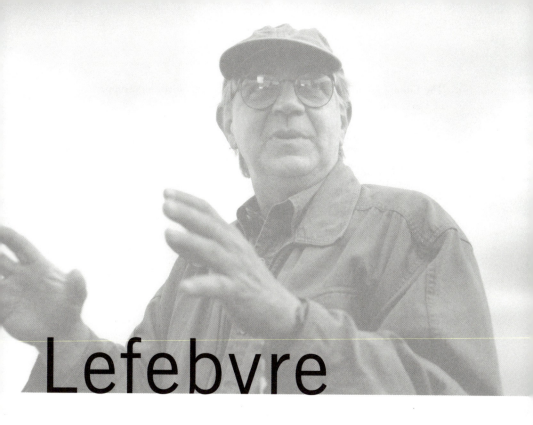

Lefebvre

vidéaste

Edited by Peter Harcourt

The Toronto International Film Festival gratefully acknowledges the support of The Canada Council for the Arts for publication of this book.

The Canada Council | Le Conseil des Arts
for the Arts | du Canada

Toronto International Film Festival Group
2 Carlton Street, Suite 1600, Toronto, Ontario, M5B 1J3 Canada

The Toronto International Film Festival Group is a charitable, cultural and educational organization dedicated to celebrating excellence in film and the moving image.

Copyright © 2001 The Toronto International Film Festival Inc.
All rights reserved.

National Library of Canada Cataloguing in Publication Data

Main entry under title:
 Jean Pierre Lefebvre : vidéaste

Includes bibliographical references.
ISBN 0-9689132-0-2

1. Lefebvre, Jean Pierre, 1941– –Criticism and interpretation.
I. Harcourt, Peter, 1931– II. Toronto International Film Festival
PN1998.3.L44J42 2001 791.43'092 C2001-901622-0

The Canadian Retrospective programmed at the 2001 Toronto International Film Festival is generously sponsored by

Distributed in Canada by Wilfrid Laurier Press
Website: www.wlupress.wlu.ca

Cover and text design: Gordon Robertson

Printed in Canada

For Miche

Contents

| xi | Preface
Piers Handling |
|---:|---|
| 1 | Snapshots from Quebec
Jean Pierre Lefebvre |
| 17 | The Music of Light: The Video Work of Jean Pierre Lefebvre
Peter Harcourt |
| 53 | A Conversation with Jean Pierre Lefebvre
Peter Harcourt |
| 67 | The Concept of National Cinema
Jean Pierre Lefebvre |
| 79 | Filmography
Robin MacDonald |
85	Selected Bibliography
89	Acknowledgements
90	Text Sources
91	Illustration Sources

Les secrets pour soi-même ne sont ni des secrets ni des poèmes, ce sont des traces d'enfance.

Ils doivent mourir. On doit les parler tels que la bouche, trop près du coeur et à peine consciente de remuer, les a imposés à une main blessée —peut-être même coupée.

Depuis ce jour, cependant, j'ai compris que mon suicide serait de rester fidèle au Temps.

JEAN PIERRE LEFEBVRE
From "La Fleur carnivore"
(1962–63)

Preface

Why a book on Quebec filmmaker Jean Pierre Lefebvre? And why, more specifically, a book on his video work? Since his first short was made in 1964, Lefebvre has produced an impressive body of feature films (twenty-three in total) and won numerous prestigious international awards, including the 1982 International Critics' Prize for *Les Fleurs sauvages* at the Cannes Film Festival. Many of the new generation of anglophone filmmakers — among them Atom Egoyan, Jeremy Podeswa, Bill MacGillivray and Bruno Pacheco —have cited Lefebvre as a formative influence. Despite these achievements and honours, he remains virtually unknown in English Canada, and has all but disappeared from the memory of his fellow Québécois.

Culture, the social and artistic expression of communities and nation states, is what defines us, makes us distinct and different from other communities and countries. Collective memory is one of its essential underpinnings, and a national loss of memory is a serious threat to culture. Individuals who suffer from selective short-term memory loss have trouble navigating parts of the world; they require help from time to time but can still function. However, someone who suffers from Alzheimer's disease becomes in the end almost helpless, reduced to an infantile state. I would argue that memory loss can afflict a nation as it does an individual. A nation's memory can also be obliterated, and is essential to continuity.

Jean Pierre Lefebvre belongs to a generation of filmmakers who created the Quebec and Canadian cinemas. Like him, most of them have been forgotten, their artefacts dim memories from a fading past. Gilles Groulx, Don Shebib,

Claude Jutra, Don Owen, Pierre Perrault, Allan King, Gilles Carle: all are seminal names in our film history. I doubt that many Canadians, beyond a few academics and critics, have seen more than one of their films. And younger filmgoers are not likely to have heard of them at all.

In the case of Jean Pierre Lefebvre, this is a significant lapse in our collective memory. As Peter Harcourt has argued for years, he is an artist worthy of comparison with some of the most significant filmmakers of his generation. Lefebvre has fashioned work of great cinematic distinction and emotive power. His is a deeply compassionate vision, examining and questioning the role of the individual within society, history and the landscape. Lefebvre's project cannot be reduced to a sentence or two; the films reflect the tumultuous, complex decades of post-Duplessis Quebec.

Although Lefebvre's body of work is remarkable both in its depth and originality and also in the sheer number of films produced, in recent years it has become increasingly difficult for him to make feature films on a regular basis. Undeterred, he has continued to create images, using video instead of film. Like Jean-Luc Godard, another filmmaker with an equally individualistic sense of image-making, Lefebvre has used video almost as a research tool to extend and examine issues central to his art. And the video work of these two distinguished filmmakers must surely hold lessons for the next generation of digital video artists.

Twenty years ago, Lefebvre was the subject of a major retrospective that toured the country. A book-length study titled *Jean Pierre Lefebvre* by Peter Harcourt was published to accompany that programme. It is appropriate that he now returns to consider with great sensitivity the five-part video project, *L'Âge des images*, which Lefebvre made in the mid-nineties. It is also entirely appropriate that Peter Harcourt, a great champion of our own cinemas, has edited the first volume of what we at the Festival plan to turn into an ongoing programme of retrospectives and publications dealing with important issues and personalities in Canadian film history.

Piers Handling
Director, Toronto International Film Festival
July 2001, Toronto

Jean Pierre Lefebvre

Snapshots from Quebec

Everything is a question of point of view: this is the inevitable realization of creators in a minority culture like ours in Quebec. In the same way, I discovered the hugeness of our pet Labrador when my five-year-old son took a snapshot of the dog from his own angle of vision. To know the true nature of Québécois cinema, then, one has to put oneself on the level of Quebec. It's regrettable that there has never been an American remake of a Québécois film. Regrettable for theoretical study, that is! But one could make a comparative study of Godard's *À bout de souffle* (1959) and its American remake, *Breathless* (1983).

One would be immediately struck by two antagonistic points of view: that of Godard, the European, who vandalizes the form, then integrates it with the subject; and that of Jim McBride, the American, who gives back to the form the academic conventions of spectacle.

Québécois cinema is situated somewhere between the two points of view, and to speak to you frankly and subjectively about our cinema, I am sending you these snapshots from my own point of view.

In English Only

My mother was born in 1906 with, I do not know why, a passion for *les images* and music. (She was herself an accomplished musician.) She was twenty-one years old when talking pictures were born and she was carried away by the American films of the 1930s, especially the musicals that filled our screens almost exclusively.

My mother, like the vast majority of Québécois of the period, neither spoke nor really understood English. Cinema was for her then a kind of waltz of sounds and images through a dream landscape. This was probably why she judged films on only one criterion: the film was good if it made her laugh or cry.

Censorship

Until 1968, one had to be sixteen years of age to go to any cinema in Quebec, and the films were heavily censored to make them accessible to all—sixteen years and over, that is. Québécois censorship went beyond the standards of prudery instilled in American cinema decades earlier. Either it was a total ban: for example, *The Wild One* by Laslo Benedek, *The Pilgrim* by Charlie Chaplin (because the film mocked religion), *À bout de souffle* by Godard (which I personally saw in Syracuse, New York); or it was mutilation of sound and image (optical sound tracks were often perforated to eliminate vulgar or dangerous words: I believe the most famous case was *The Apartment* by Billy Wilder, where all references to Shirley MacLaine as "mistress" were systematically removed). For young people under sixteen years of age, there were only two kinds of opportunities for moviegoing: (1) at Christmas, Easter and All Saints' Day, when commercial cinemas invariably presented a Walt Disney film preceded by an American cartoon (it was no doubt at one of these screenings that I fell in love with the work of Tex Avery) and perhaps a short film from the National Film Board of Canada, and (2) on Saturday afternoons throughout the year, in the basement of Catholic churches, where double features were presented—always American and always adventure or war films.

Although I was born in 1941, it wasn't until 1957 that I obtained the sacred right, as impatiently awaited as a first love, of going to the cinema. I can also publicly admit for the first time that cinema made me a great sinner. During Easter vacation particularly, I would stick my nose into church for the afternoon service, just to see who was officiating, then I would cut out to the movie house a few streets away to catch the matinée.

Drive-In

But earlier on, in the 1950s, when the Canadian dollar was worth 25 percent more than the American, the Québécois descended en masse to the States. And part of the trip was the sacred family ritual of the double feature at the drive-in.

Sometimes in my dreams I see again whole scenes from *Show Boat, An American in Paris, Annie Get Your Gun, Rose Marie, The Great Waltz* and many others.

Culture and Entertainment

In 1951 I began my classical education in a Catholic boarding school. On rainy holiday afternoons they showed us films of the same genre as we had seen in the church basement: *Robin Hood, The Best Years of Our Lives, The Court Jester, Joan of Arc, Lily, Mrs. Miniver* and numerous Westerns, among which those of John Ford left an indelible impression on me.

Obviously, the clergy saw cinema as pure and simple entertainment—much as politicians past and present have done—containing no cultural value, for as our education and that of our teachers was French from France, then real culture, it followed, must also be French, even if for reasons of morality they refused to show us French films! American films, however, were truly moral, showing good conquering evil and married couples in twin beds . . . totally inoffensive, they believed. In consequence of this dichotomy between Culture and Entertainment, there was no question of recognizing ourselves, or our culture, in films. On the contrary, our

teachers wanted to break us of our Québécois language and accent.

But outside the halls of learning, where for ten months of the year for eight years they used so much energy to make us the élite of tomorrow, the times were changing—especially in the world of communication, with the incredible expansion of radio and television.

To keep up with the times, Canada opened its first English television station in Toronto, and its first French station in Montreal, in 1952. In 1954, the National Film Board, still located in the nation's capital, Ottawa, decided to produce for television. Two years later it would relocate to Montreal.

The Other Cinema

Several film clubs were born in 1949, but they only began to proliferate, under the control of the Catholic church, in 1953. The church believed that it was time to combat the materialism of cinema in general, and American cinema in particular, by studying films that put forward more human and spiritual values.

The more notable among such films were *Ladri di biciclette*; *Sciuscià*; and *Umberto D* by De Sica; *Roma, città aperta*; *Paisà*; *Germania, Anno Zero*; *Francesco, Giullare di Dio* by Rossellini; *La Strada* by Fellini; and *Jour de fête* by Tati.

For me, it was like suddenly perceiving the dark side of the moon of life, of cinema, and of the world. Until then I had no idea of the existence of such alien cultures.

But that was not all: at the same time I made another great discovery through the first moving pictures that I saw of Quebec and the Québécois, both on television and at the film club of my college—the film club that I was passionately involved in from the age of fourteen, deciding at fifteen that I wanted only to make films. I remember the *coup de foudre* very well. Having seen my total devotion to the cause of good cinema, the priest in charge of our club bestowed on me one afternoon an incredible, and fatal, honour: I was allowed to watch, alone in the chemistry lab, *Alexander Nevsky* by Eisenstein. We had been formally forbidden to watch any "Communist"

film, under pain of mortal sin. Only the good priests, especially the philosophy teachers, screened such films for "analysis." The film impressed me as so many other foreign films had; but I also literally tore my hair out wondering why they had forbidden this film, why it was a mortal sin to watch. I was astonished that this evil Communist film even ended with a line from the Holy Bible: "Those who live by the sword, die by the sword" (you may remember that by one of the ironies of history and propaganda, those are the same famous words that influence the hero of *Sergeant York* by Howard Hawks).

Propaganda and Folklore

Until 1956, when the National Film Board moved to Montreal, to the heart of Quebec and the French-speaking population, the images we had of ourselves were of two sorts. First, there were those serving us propaganda, the *raison d'être* of the National Film Board, created in 1939 by the Scotsman John Grierson at the request of the Canadian government, and second, images of folklore.

Two priests had explored on film the great landscapes, geographical, human and religious, of the Québécois nation: Albert Tessier (1895–1976) and Maurice Proulx (1902–1988). Their documentaries were lyrically *pro patria*, showing the "true" Québécois, i.e., the peasants, who sweated blood to clear the harsh majestic country that God had so generously given them. This, incidentally, is the same Quebec that the National Film Board was trying to sell to immigrants from other countries.

Also, beginning in 1944, around twenty independently produced French-language features appeared, all with heavy, melodramatic subjects. None have stood the test of time, except perhaps as documents, like *La Petite Aurore*

Hommage à notre paysannerie
Albert Tessier

La Petite Aurore l'enfant martyre
Jean-Yves Bigras

l'enfant martyre (1952), which recounts the horrific physical abuse of a young girl by her stepmother. Most of these films enjoyed great public success while taking advantage of a certain narrowly defined nationalism. But they constitute nonetheless an important step in the "Québécisation" of our imagination, saturated as it was, and still is, by the language and images of the United States.

Happy Endings

To sum up thus far, one might say this: the images my mother, I, and all the Québécois absorbed until 1956 were under the direct control of a number of "gods," each more inaccessible and paternalistic than the last: the god of Hollywood, the god of the Catholic Church, and the god of Canadian federalism, whose official voice was the National Film Board (which took twenty years to give its filmmakers the right to sign their own work, the real "author" heretofore being the NFB itself).

We were living in a kind of promised land of happy endings: those of the American movies, those of French culture with its rewards for the educated and privileged here on earth, heavenly rewards for the less privileged but faithful, and finally, the happy political endings of a confederated Canada, great and strong, completely dominated by an anglophone cultural industry rooted in the USA.

Obviously, all of this left little room, if any, for the emancipation of our Québécois culture, our language, our imagination ... our identity, in other words.

Chance and Necessity

How on earth then did we Québécois, dominated by these various gods, break our silence and begin to play with images and cinema, that inaccessible and expensive tool so long forbidden to the children we were? It was on one hand chance, and on the other the necessity of communication.

By chance I mean a number of small events that came fortuitously together: the development of lightweight cameras and portable sound equipment that "democratized" cinema; the demand created by television, which the NFB struggled to fill, becoming less and less able to censor its own product; and the arrival of new filmmakers, inexperienced and naive, who gave freshness and audacity to their films.

By "the necessity of communication," I mean that the clergy and the politicians could no longer keep out the rest of the world. Not even Maurice Duplessis, Quebec's little premier-dictator who held the laws of God and man in his hands for twenty years, between 1936 and 1959, could keep our minds imprisoned forever.

A personal example: for me it was the Algerian war that awakened my political conscience and knocked France and its culture off its pedestal. Also, at the University of Montreal in 1960, just after the death of Duplessis and the beginning of Quebec's emancipation, we students soon realized that sometimes we knew more than our professors, whose teaching was restricted by tradition. For example, the famous Index forbade, on pain of mortal sin, the reading of almost all of the major works of world literature.

Candid Eye

From 1956 on, we witnessed a progressive reversal, on every level, of the gods that had dominated us.

Les Raquetteurs
Gilles Groulx, Michel Brault

How was that reflected in the world of cinema? It was as banal and as extraordinary as a love story: we noticed each other, we met, we were won over, we exchanged among ourselves, we changed, we dreamed, and sometimes we produced children. . . .

Having no intention of giving a history course, I will keep to the major moments and to the spirit that animated each step of our cinema's growth.

If the pot began to simmer in 1956, especially at the NFB, it was in 1958 that it boiled over with thirteen short films for the television series "Candid Eye" on the one hand, and the film *Les Raquetteurs* shot by Gilles Groulx in collaboration with Michel Brault and Marcel Carrière on the other.

It is interesting to note that the series "Candid Eye" was essentially the work of anglophones at the NFB, while *Les Raquetteurs* was the work of a small group of francophones. Though both the series and the short film by Gilles Groulx originated in a candid and spontaneous observation of reality and people, only *Les Raquetteurs* came within an inch of being banned by the directors of the Film Board. Why? In my opinion, because they sensed they were losing control of the way a people and its culture were represented with this film. The official reaction to the film—as to other later ones, such as *Cap d'espoir* (Jacques Leduc, 1969), *On est au coton* (Denys Arcand, 1971), and *24 heures ou plus* (Gilles Groulx, 1976), all three of which were strictly banned—only served to reveal the intense fear Canada's "official voice" had of dirtying its hands and its films with "marginal" subjects or subjective interpretations. I had a taste of the same medicine in 1968, when the NFB held up until 1970 the finishing of one of my films, *Mon amie Pierrette,* for questions of "aesthetics." We had shot the film stressing the reds to give the impression of an 8mm film; the young adolescent had bags under her eyes; the actors spoke in Québécois about . . . nationalism. In short, it was too vulgar for the official voice of Canada to give it its imprimatur. (How many times has the word "vulgar" been attributed to the works most essential in the evolution of our culture?)

Cinéma Direct

So, with a candid eye and the global spirit that prevailed, we noticed each other, we met . . . and we were soon attracted to each other.

Until then, cinema had never gone into the streets; real people had never been able to reveal themselves, in word or image. But now a second stage began, called *cinéma direct*.

Once again, the most representative film of this period was by Gilles Groulx, *Golden Gloves* (1961). Once again, the shooting was a collective effort, with Guy Borremans, Michel Brault, Claude Jutra and Bernard Gosselin. What is more, since 1959, after much internal warfare at the NFB, a "French" team had come into existence and it enjoyed relative autonomy in the handling of its projects.

Cinéma direct for the first time gave a voice to those in front of the camera as well as to those behind it, as we sought to get to know each other. In many cases we spoke too much, but why not? It was so good to break our ancestral silence. (Julien Green has said that we create to speak for those who do not have the chance to speak themselves, or who have been reduced to silence.) The beginning of the Quiet Revolution in Quebec was sweetly euphoric when, in 1959, we began a new era with the death of Maurice Duplessis. The Liberal Party, under Jean Lesage, came to power in 1960, and within their ranks was René Lévesque.

South Pacific

Let's stop for a minute in 1961.

My father died in February, my mother in August, on the very day I was to interview François Truffaut for the independent magazine *Objectif,* which we began in 1960 and abandoned in 1967, when most of us had become filmmakers ourselves.

A few months before her death, my mother, still crazy about the movies despite a serious illness of many years, asked to be taken to see *South Pacific* for the thirteenth time. . . .

If, along with my colleagues at *Objectif,* influenced no doubt by *Cahiers du cinéma,* I had rediscovered American cinema, *South Pacific* still represented for me the bottom of the barrel of "propaganda as spectacle." Could I then refuse my mother one of her few pleasures? Of course not, for I wasn't Marxist either!

It was the last time she would see a film on the big screen. . . .

I remember that from that day on I was haunted by the question: how could I tell my mother what I thought of this film, and what it represented?

I could come up with only one answer: to make films myself that spoke about her, about our country and our language, films that looked more and more like us, and that could offset perhaps the omnipresence of American culture.

The question, and the answer, have never disappeared: each of my films remains a kind of secret dialogue with my mother.

But at the time, with no film schools in Quebec, or in Canada for that matter, I studied French literature until 1962. I then travelled to Paris, where for a year I watched on average four films a day. (In Quebec we had no *cinémathèque* either, though we worked through almost the entire repertoire of that of Rochester, New York.) That was my film school.

À tout prendre, Claude Jutra

Cinéma-vérité

On my return in 1963, I found that two feature films had just changed the face of cinema in Quebec by combining the styles and methods then under experimentation: *Pour la suite du monde* by Pierre Perrault and Michel Brault, and *À tout prendre* by Claude Jutra. Both films were *cinéma-vérité*.[1]

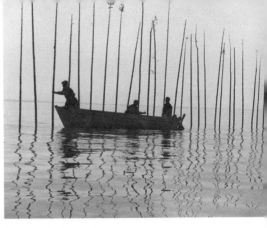

Pour la suite du monde
Pierre Perrault, Michel Brault

Looking back, we can see how logical this step was.

We had met and been seduced by the "candid eye" style; we began to exchange with *cinéma direct;* but we had to go further, to investigate the present and the past at the same time.

Chronique d'un été
Jean Rouch

Between 1958 and 1960, Pierre Perrault had made a beautiful ethnographic inventory with the series *Au pays de Neufve-France* (thirteen half-hours in collaboration with René Bonnière); in 1961, Michel Brault did the photography for *Chronique d'un été*, shot in France by Jean Rouch, which we young filmmakers considered the manifesto of *cinéma-vérité*.

In *Pour la suite du monde,* the two filmmakers decided to place the people of Île-aux-Coudres in the St. Lawrence River in a certain "situation": the return to porpoise fishing, which had been abandoned at the beginning of the century. For his part, Claude Jutra, who had participated in every step of the evolution of our cinema in the 1950s, turned the camera on himself, making *À tout prendre* both an autobiography and a psychological study.

We were a million miles from the gods that had dominated us: suddenly, everything was happening on the level of authentic testimony transmitted in words and images. As a consequence, aesthetics and all formal dictates, political or moral, became secondary. A new kind of aesthetic was

Le Chat dans le sac
Gilles Groulx

born, and it was spreading, a little at a time, through the rest of the world of cinema.

Time/Money

I watched all this from the outside, fascinated by all that had been undertaken since 1956, but a little skeptical at the concept of *cinéma-vérité,* maybe at any concept of "truth." I told myself that one day I too would have to stop being part of the audience and jump into the water.

It was in 1964 that I took the plunge.

In January and February I made a short of twenty-four minutes, with $300 and a Bolex borrowed from a friend.

In August, I came out of the Festival of Canadian Cinema in Montreal completely transformed by a viewing of *Le Chat dans le sac,* the first feature by Gilles Groulx—the same Gilles Groulx who this time had provided the missing link by bringing to a dramatic film the lessons of "Candid Eye," *cinéma direct,* and *cinema-vérité.* For the first time, watching a feature from here, I identified completely, as a Québécois and as a budding filmmaker. So completely that by the end of the year I attempted my first feature, *Le Révolutionnaire.*

We had to be crazy or naïve or both.

We bought five hundred dollars' worth of 16mm negative; one person had an Arriflex, another a Nagra; and the twenty-five people who took part in the shooting paid ten dollars each for food. We began shooting on Boxing Day and finished New Year's Eve.

We were shooting in the country, in the open, in the cold. The camera and the actors were freezing. . . . What to do?

Put the camera on the wood stove with the actors around it, and as soon as all thawed out, rush outside, start the camera and shoot . . . until everything froze again.

You can imagine the final result: long sequence shots, no reverse angles, no cutaways.

If I had shot in a studio, with lots of time and money, I would probably have shot more conventionally, more "American" even (up to a certain point, because on the level of shooting style, I had always been an unreserved admirer of John Ford, the most economical of American directors).

During the editing, I realized I had been the victim of a series of imperatives—weather, time, money—that gave the film its own style, its nationality, even its meaning, as my subject was the immobility of a group of intellectuals.

Form/Content

So it was chance, as well as the necessity of communication, that taught me and all Québécois filmmakers our craft, that engendered a "quiet revolution" of form, because, paradoxically, the content was most important to us.

I saw *Golden Gloves,* by Gilles Groulx, once again several weeks ago. Today, television—for which it was made in 1961—would certainly refuse to air the film for technical reasons: the high-contrast photography, the abrupt zooms. They, however, are part of the film's great beauty and authenticity. It's always a question of point of view, isn't it?

In cinema, most directors do not want to cross the border of the figurative, especially American directors who, as in the example of *Breathless,* prefer linear verbal stories rendered in beautiful images (that could explain in part the success of *The Decline of the American Empire* [1986] in the United States, since it consists almost entirely of filmed dialogue). I am neither for nor against this phenomenon: I simply point it out.

For my part, I believe that different cultures express themselves in different forms: that these different forms are an indelible mark of individual and collective identity. To give film, at any cost, the same grammar, a few recipes for scripts, a closed star system—in short, the same form for every film—is to destroy the identity and the nationality of the work; to create a non-culture dominated by the economy and profits. To destroy, finally, the emotion, which is in my opinion the source of all creation . . . that simple love story that determines the relation between the film and its creator. For

example, I have a personal horror of shooting reverse angles, especially when we have a shoulder in the frame, because I become a third person—a voyeur instead of a participant, a passive spectator instead of an active one.

These are not abstract theories: they are simply the fruit of an emotional apprenticeship of our reality here in Quebec, which we had never seen except through the eyes of others.

Without Money

Le cinéma québécois des origines, as we call it here, was as original as it was marginal, not only for the reasons I have stated, but also because we were not preoccupied by concerns of money or profit.

In the 1960s, the National Film Board and the Canadian Broadcasting Corporation/Radio-Canada were concerned only with cultural and political profitability. In the private industry, which just barely existed, and was dependent on television, we had nothing. For example, my first feature (*Le Révolutionnaire*) had a budget of $16,000, my second $14,000, my third $35,000 . . . and these budgets included up to 50 percent of deferred salaries, which were never paid.

So our cinema wasn't born out of any tradition of spectacle or show business, despite our intoxication with American culture and the movies of Hollywood.

We must not forget that other cinemas, comparable to ours in Quebec, were being born at the same time. Many of us (except for the strict practitioners of *cinéma direct* and *cinéma-vérité*) met and exchanged ideas with these filmmakers at le Festival international du film de Montréal: Skolimowski of *Walkover*, Polanski of *Knife in the Water*, Forman of *Black Peter* and *Loves of a Blonde,* Glauber Rocha of *Deus e o Diabo na Terra do Sol* and *Terra em Transe,* and many others. And some of our films began to travel, particularly in France, where they met with considerable critical success. Within less than six years (1963–69) we made concrete the abstract literary idea that people had of Quebec. For until then, it was the poets and writers—along with the songs of Félix Leclerc and others—that had repre-

sented us abroad and carried all our anxieties and Québécois submission. Finally, the collective power of *le cinéma des origines* could help them in the work of our liberation.

Orthodoxy

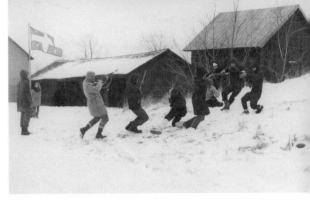

Le Révolutionnaire
Jean Pierre Lefebvre

Is it necessary to speak of the other face of Québécois cinema, which began to show itself in 1968 when the federal government decided to create the Canadian Film Development Corporation (now Telefilm Canada) to invest in, or lend money in support of, Québécois and Canadian cinema?

It is a tale of a slow, and then—in the 1990s—a rapid move towards orthodoxy. Much the same as the one made by the filmmakers named above: Skolimowski, Polanski, Forman, Rocha.

Orthodoxy in the form, and so in the content, of our stories, which must resemble more and more those of other countries to have access to their markets.

If our cinema until 1968 garnered many cultural and political dividends, it was now necessary to "manage" it better.

We are still in the same position. More than ever.

Since 1975, Quebec has had its own financing body, la Société générale des industries culturelles (SOGIC), which pays more and more heed to the decisions of Telefilm Canada, because the cost of films keeps on climbing. Fifteen years ago, a feature film in Quebec cost between $150,000 and $300,000; now it is between $1.5 and $5 million.

The financial responsibilities have forced the majority of Québécois films to choose subjects according to the demands of the market. Documentaries, *cinéma direct* and *cinéma-verité* are almost rejected out of hand by television and investors. And the film schools thrust into the workplace fifty times more people than our small industry is capable of absorbing.

In short, Québécois cinema has evolved in much the same way as Quebec, conforming in spite of itself to economic imperatives and to the direct

and indirect pressures of the USA, which controls our distribution markets as well as prime-time television.

Conclusion

My closing is a little melancholy, I'm afraid. But for the moment I cannot imagine a happy ending, either in the long or short term. The future of Québécois cinema and Québécois culture depends both on the strength of our political will to hang on to our "marginal" history and language, and on the passion of our creators to illuminate, once again, that political will.

But why must we survive, we sometimes ask. Why not follow the current, and flow, body, soul, language and imagination, into the immense whirlpool of American culture?

I do not know. That need to survive springs from both chance and necessity. Or simply the pleasure of being who you are, in the place where you were born. It springs from the pleasure of not seeing, feeling or understanding the world in the same way as everyone else, and from the pleasure of exchanging that understanding with others—our different points of view.

Finally, it is a need to continue my secret dialogue with my mother and, through my films, to let my children share that conversation too.

Quebec, 1989
Translated by Barbara Easto

Notes

1. *Cinéma-verité* differs from the other documentary technique, *cinéma direct*, by its emphasis on interviewing, and in general by the active involvement of the filmmaker. Both techniques were of course made possible by the development of lightweight cameras and recording equipment.

Peter Harcourt

The Music of Light

The Video Work of Jean Pierre Lefebvre

> My idealism would be gratuitous were it not rooted in a Quebec cinema that long ago revealed to me the depth of our culture, the passion of our perception of it, and the necessity of that passion. – JEAN PIERRE LEFEBVRE (1976)

Prologue

Writing about Jean Pierre Lefebvre twenty years ago, I claimed that, at their best, his films combine the formal authority of Michael Snow with the compassionate humanity of Jean Renoir. I would still make that claim. From the 1960s to the 1980s, they were as much celebrated at international festivals as are the films nowadays of Atom Egoyan and Denys Arcand. Along with other key works, such as *Pour la suite du monde* (1963) by Pierre Perrault and Michel Brault, *À tout prendre* (1963) by Claude Jutra, *Le Chat dans le sac* (1964) by Gilles Groulx; and *La Vraie Nature de Bernadette* (1972) by Gilles Carle, the films of Jean Pierre Lefebvre helped to consolidate a sense in Quebec of an emerging national cinema.

Not only did Lefebvre's *Il ne faut pas mourir pour ça* (1966) share with Allan King's *Warrendale* (1966) the Grand Prize at the Fifth Festival of

Il ne faut pas mourir pour ça

Canadian Films in Montreal in 1967, but it was also the first Canadian film ever shown at Cannes. *Les Dernières Fiançailles* (1973) won a number of European prizes in 1974, including the Prix de l'Organisation catholique international du cinéma—the top film prize offered by the Catholic church throughout the world. Similarly, *L'Amour blessé* (1975), *Le Vieux Pays où Rimbaud est mort* (1977) and *Avoir 16 ans* (1979) were all shown at Cannes to considerable acclaim, as was *Le Jour "S"* (1983). *Les Fleurs sauvages* (1982), an intimate study of family life, won the International Critics' Prize in 1983.

Although none of these films ever enjoyed a theatrical release in English Canada or the United States, Jean Pierre Lefebvre remains the most prolific and innovative of all Canadian filmmakers. Part of that generation of the 1960s when young filmmakers were reinventing cinema as they were reinventing life, Lefebvre has remained true to the idealism of that period. Like Jean-Luc Godard, he has refused to surrender to the industrial demands of the globalized film industry. Finding it increasingly difficult in recent years, however, to finance his innovative theatrical features, Lefebvre has —again like Godard—turned to video.

Although Lefebvre didn't start working professionally with video until the late 1980s, Godard began in 1975. Collaborating with Anne-Marie Miéville, in *Numéro deux* Godard made a number of video studies of working-class life in the south of France and put them together on film. Throughout the 1970s, he and Miéville also produced two important series

for French educational television; and in the late 1970s Godard offered lecture/presentations at the Conservatory of Cinematographic Art at Concordia University in Montreal. While there, he began to think of an extended video series on a personalized history of cinema.

Indeed, Godard's eight-part video essay, *Histoire(s) du cinéma* (1988–98) and Lefebvre's five-part *L'Âge des images* (1993–95) have many things in common. They are both denunciatory. They both address the failure of cinema to sustain its early promise—Godard in terms of the high culture of nineteenth-century aesthetics; Lefebvre in terms of the disappearance of social concerns that characterized the early cinema of Quebec.

If Godard's *Histoire(s)* reach outwards towards culture, Lefebvre's *Images* reach inwards towards the personal. Godard, whose life is childless, looks backwards towards the past. Lefebvre, who has three young children, looks forward towards the future. These two sets of video essays parallel one another in challenging ways. But before looking in detail at the videos of Jean Pierre Lefebvre, let us look briefly at the achievement of his films.

The Films

To my mind, culture is quite simply the sum of what we have created and of what we are creating. Everything depends upon that small semantic nuance, to create—rather than simply make or reproduce. (1999)

With twenty feature films to his credit, Lefebvre is unique among Quebec filmmakers in that he did not begin in documentary, and except for two short periods, never worked at the National Film Board. Like Godard, Lefebvre began as a critic. From the outset he was a commentator on the emerging Québécois cinema, and on the role films had to play in confirming cultural identity. His many articles for *Objectif*, *Cinéma Québec* and more recently for *24 Images*

argue his belief in a national cinema—a cinema unique to a particular place and time.

The most thorough presentation of his position is "The Concept of National Cinema," published elsewhere in this volume. Lefebvre insists that artistic creation is as elemental and necessary an impulse as the need for food and shelter. Just as children take possession of the spaces they inhabit by drawing on the walls, so a nation defines its boundaries by its cultural signs.

In this belief, Lefebvre was not alone. In 1973 Jacques Leduc, whose *Tendresse ordinaire* (1973) and *Chronique de la vie quotidienne* (1977–78) represent a national utterance as passionate as Lefebvre's, suggested in an interview in *Le Cinéma québécois* that

> . . . it's necessary to find a cinematic language that's authentically Québécois . . . a language by which people will recognize a cinematic form that's latent within us, a little like Americans can find themselves in the Westerns of John Ford.

These arguments have never been understood by bureaucrats. Nor have they been understood by academics. Nowadays, within the ideology of transcendent globalization, such a position is generally dismissed as essentialist—a parochial attitude that in today's world one should really grow out of. But as Lefebvre well knows, one grows out of it only by surrendering one's voice. For the Québécois, as we have seen in recent films by Denys Arcand and Léa Pool, that also entails surrendering one's language.

One of the problems for both English and French Canadian filmmaking is that people do not want to make a *different* cinema. They want to compete in the international market so that they can make films that are not different but the same as commercial American films. (1981)

Traditionally, Jean Pierre Lefebvre has taken pride in making his films as inexpensively as possible. Although viewers may find an ascetic dimension in his films, the reasons were not only ascetic. They were also economic

and political. Like many of his colleagues at the time when he began his career, Lefebvre believed that in order to make films for his own people, he had to make them cheaply enough to recover their costs within Quebec. This led him to an aesthetic that was based on a series of refusals. These refusals made possible, of course, an equal number of espousals. Within every denial was an affirmation. From this way of thinking evolved a distinct cinematic voice.

To begin with, there is an absence of close-ups. Mid-shots and long shots abound. This decision results in at least three effects. First of all, the individual psychology of the characters is privileged less than the relationships between them. Although Lefebvre's films concern individuals, their place in a social world is equally strong. Secondly, Lefebvre's refusal of action/reaction shots imposes a distinctive pace on his films. It also alters the relationship that spectators establish with the spectacles that Lefebvre has devised.

That Lefebvre's films are slow is the complaint most often made about them. What this comment really means is that Lefebvre's films rarely invite identification between spectator and spectacle. The pace necessitates a more reflective viewing than the standard Hollywood film. Less concerned with plot than with the presentation of characters within a landscape, Lefebvre's films invite the question "what is happening now?" rather than "what will happen next?"

Thirdly, the privileging of the long shot emphasizes the space within the frame. In Lefebvre's films—as in many Québécois films of the 1960s and '70s, especially in the work of Pierre Perrault and Jacques Leduc—the landscape is as much a protagonist as the characters. Whether it be the interiors of Abel's *chambre de bonne* in *Le Vieux Pays où Rimbaud est mort* or the frozen winterscapes of *Les Maudits Sauvages* (1971), the environment is as much a part of the content of the film as anything the characters do or say.

Lefebvre's cinema is supremely a semiotic cinema. Even more than the films of Jean-Luc Godard, the films of Jean Pierre Lefebvre go beyond the literal value of the images they represent. As his own graphic designs for each of his works would indicate, he thinks of film structure in geometric terms. Indeed, in *Jean Pierre Lefebvre* published in 1971, Dominique Noguez

Le Vieux Pays où Rimbaud est mort

suggested that *La Chambre blanche* (1969) "is a film on the number two." Simultaneously Lefebvre's most intimate and most hermetic achievement, this film presents characters that are tangible and real but which also refer to ideas that must be inferred—*decoded* if you will—from the overall structure of the film.

As Michel Euvrard has suggested in *Le Dictionnaire du cinéma québécois*:

> Lefebvre is less the cousin of Godard than the nephew of Bresson; he has embraced Bresson's view that "the art of cinematography is the art of showing nothing, or rather, the art of representing nothing. The image shouldn't be a representation, it should be a sign."

Throughout the work of Jean Pierre Lefebvre, this asceticism determines the aesthetics of the films. At the same time, the individual films are astonishingly different from one another. These differences are organized around a concept of modes that could be classified as the personal, the political and the pastoral. Of course, these modes all intertwine within the individual films. At times, however, one mode will predominate and determine the centre of gravity of a film.

On the one hand, we have the most political films, *Le Révolutionnaire* (1965) and *Les Maudits Sauvages*. Both these films directly address a politi-

cal reality. *Le Révolutionnaire* mocks the desire of a few Québécois at that time to stage an actual revolution in imitation of Cuba; *Les Maudits Sauvages* exposes the exploitation of Canada's native peoples by the French-Canadian settlers.

On the other hand, we have the most pastoral films, *Les Dernières Fiançailles* and *Les Fleurs sauvages*. *Les Dernières Fiançailles* is a loving evocation of the final

Les Maudits Sauvages

hours of an old couple's life; while *Les Fleurs sauvages* is an equally loving presentation of generational care and conflict, set in Lefebvre's country home in the Eastern Townships. Between these two modes is Lefebvre's most personal film, *La Chambre blanche*, a celebration of married life, also shot in Lefebvre's home. But *La Chambre blanche* acknowledges the violence of the surrounding world, so it is also political. *Ultimatum* (1971–73) was Lefebvre's response to the October Crisis, to the presence of *actual* violence in Quebec at that time. It thus extends the sense of threat present in *La Chambre blanche*, but is at the same time extremely personal. Finally, the autobiographically personal *Au rythme de mon coeur* (1980–83), while documenting Lefebvre's tour across Canada to the many film cooperatives in which he was giving workshops, also documents in a disturbingly pastoral way the loss of his wife, Marguerite Duparc, to cancer, and the appearance of a new woman in his life—his current wife, Barbara Easto.

Because they all deal with individuals in a social world, we might say that films like *Il ne faut pas mourir pour ça*, *Le Vieux Pays où Rimbaud est mort* and *Avoir 16 ans* combine in equal degrees the personal and the political, as does Lefebvre's most austere film, *L'Amour blessé*—a film that depicts the lonely life of a single woman who experiences the violence of late-night radio talk shows. In combining a puppy love story, set at a summer cottage, with an examination of what it means to be Québécois, *Mon amie Pierrette* (1967) interweaves the pastoral and the political.

But this concept of modes offers only the loosest of groupings. More helpful in explaining the range of styles is Lefebvre's determination to find

a treatment appropriate to the subject-matter of each film, or (as he would put it) an "aesthetic" for each "ethic."

So in *La Chambre blanche* the parallel structures and cross-cuttings reinforce the parallel lives of its principal characters, Jean and Anne. Similarly, the virtually static camera of *Le Vieux Pays*, through the authority of its frame and the nuanced play of depth within the cinematography, recreates the visual world of Paul Cézanne. And in *Avoir 16 ans*, the deliberate camera movements, the extended width of the CinemaScope screen and the prolonged takes imprison the spectator within the structures of this film, just as the protagonist, Louis, is imprisoned within the structures of the educational system.

Finally, not only do the extended takes and slow pace of *Les Dernières Fiançailles* mimetically recreate the rhythms of an old couple's final moments on earth, but the washes of blue and yellow suggest the Easter colours that would have been part of their religious imagination, just as the flourishing apple blossoms at the end suggest the Christian cycle of birth, death and rebirth—a "resurrection" if you will, assisted by imaginary angels!

For thirty years I've been saying the same thing—it's so simple and at the same time so disturbing: the Québécois cinema is the very image of Quebec, and Quebec the image of the Québécois cinema. (1988)

Throughout Lefebvre's work, within the self-imposed austerity of his approach, there is an enormous diversity of individual styles; he always thinks through the formal requirements of each new film. While working at the National Film Board for *Mon amie Pierrette*, Lefebvre simulated the "grab-shot" techniques, endemic to documentary, that characterized NFB productions at the time; while for *Jusqu'au coeur* (1968), he drew upon all the studio facilities, back projection and stock shots that the Film Board could provide.

Similarly, if for *Le Révolutionnaire* the takes are short, the decision to make them so was as much practical as aesthetic. Lefebvre was shooting out-of-doors in freezing weather with an unblimped 16mm Arriflex, and both the camera and the filmmakers would have frozen had they stayed out too long. And with very little money but with the desire to make a film

Mon amie Pierrette

about a lonely woman who listens to late-night radio throughout her sleepless nights, Lefebvre shot *L'Amour blessé* in 35mm, a film that offers a monotone of images but a rich montage of sounds.

In a monograph prepared for the British Film Institute in London, Susan Barrowclough suggested that Lefebvre's films could provide a model for filmmakers working within emerging cultures in third-world countries. In many ways this is true. If historically it has been the innovations of Godard that have liberated emerging cinemas around the world, Lefebvre's work, in its continuity, arguably provides a better model.

Important though Godard is, his work, like that of all great modernists, largely engages intellectuals. Lefebvre's work, on the other hand, makes a strong emotional appeal despite being highly innovative. If we give ourselves up to the pace of the films, their unfamiliar strategies will seep into our subconscious. Although elliptical, Lefebvre's work is not allusive. Once we understand its conventions, it can inspire the human delight that we feel for the best of folk art.

In its basic philosophy, the work of Jean Pierre Lefebvre is profoundly traditional. It endorses human values and celebrates compassion. A deep compassion is all that Abel can bring to the world—whether in *Il ne faut pas mourir pour ça*, *Le Vieux Pays où Rimbaud est mort* or in *Aujourd'hui ou jamais* (1997). Throughout this trilogy, Abel (Marcel Sabourin), is a kind of Québécois everyman. He cannot change the world, much as he would like to. He can simply experience its beauty, observe its suffering and, when the missing father returns, overcome his resentment and offer forgiveness.

> We know intuitively that the only guarantee of our individual future is the destiny of the collectivity—just as it is with wolves. (1988)

In most of Lefebvre's films, serenity comes with acceptance. At the end of *Le Vieux Pays*, no matter how much he has been moved by the people he has met, Abel must return home to the frozen emptiness of Quebec because that is where he belongs. Having visited the old country to see if his ancestors still resemble him (of course, they do not), he must return to the land in which he can be who he is—a Canadian *colon*, a Québécois. Similarly, immense com-

passion pervades the final take of *Avoir 16 ans*. Compassion is all the young friends have left to share in this authoritarian world that has done its best to humiliate them. Because these students challenged the authoritarian structure of the school system that confined them, they were interrogated like criminals, and Louis, the principal agitator, was even locked away for a time. So too, in order for the film to end, the wife must forgive her husband for his peccadilloes during his day of sexual adventure without her in *Le Jour "S"*. Meanwhile, within the image, from the old port in Montreal, we see the Jacques-Cartier bridge spanning the island of the city and the mainland of Quebec—making connections, as this modern couple has just done.

Acceptance, understanding, tolerance and compassion are the elements that make Lefebvre's creations so wonderful in today's commerce-obsessed and over-theorized world. Led astray by critics, many people assume that innovative form must endorse an innovative way of life, a "revolutionary" manner of thinking. Hence all the fuss about Godard in the 1960s—as if his films were going to change the world; and hence too the complete indifference to his work throughout the 1980s when he moved on to other things.

The films of Jean Pierre Lefebvre, on the other hand, were they better known, *might* change the world. Lefebvre has enormous faith in the creative imagination. That is why, traditional though they be, each film has been imagined differently. Furthermore, the audience has to imagine each film differently in order to receive its simplicities.

In an age of the visceral excitements of *Terminator II*, the simple contrivances of *Le Fabuleux Voyage de l'Ange* (1991) annoyed critics in both our official languages. The Méliès-inspired sets and the cartoon drawings by Rémy Simard seemed too simplistic for contemporary eyes. And yet, like *Aujourd'hui ou jamais*, the film deals with uncertainty and loss that leads, as generally with Lefebvre, to acceptance and renewed self-esteem.

The values that inform Jean Pierre Lefebvre's work are values we most need if life is to continue. As in Wim Wenders' *Wings of Desire* (1988), which alternates black and white with colour, *La Boîte à soleil* suggests that if we can rediscover the sunshine that has been locked away in the private boxes of our inner selves, colour may return to the world and we may all be able to smile again.

The Videos

The virtue of Québécois cinema is that it was born, and lives, in parallel with a social and political situation to which, in one way or another, it inevitably refers, for better or worse. (1971)

In 1990, Lefebvre had invested in a Sony Hi8mm video system. Having already made a couple of music videos for the pop singer Richard Séguin, he set out to master his new Hi8 technology by making a delightful record of

the wedding of some friends. Lefebvre then embarked on his major video project, *L'Âge des images*. This series of videos consists of four fifty-minute essays and a fictional feature: *Le Pornolithique, L'Écran invisible, Comment filmer Dieu, Mon chien n'est pas mort* and *La Passion de l'innocence*.

Lefebvre had become interested in video through the production workshops that he offers across Canada. The medium is so immediate and (after one has paid for the equipment) so inexpensive that, as he explains in one of the videos, it allows him to play with images as freely as *chansonniers* play their guitars. Furthermore, in a world in which film-industry strategies have escalated the cost of production, making it more and more difficult to finance personally conceived films, video allows filmmakers like Jean-Luc Godard and Jean Pierre Lefebvre to continue working with images. The video image can also critique the co-opting of the film image by commerce, a co-optation that distresses both Godard and Lefebvre, along with many of their admirers.

L'Âge des images examines televisual representations—the capture and construction of video signs. Although each video essay is a separate entity, collectively they constitute a sustained investigation. They speak across one another like the serial panels of a religious pentaptych.

Le Pornolithique

Other people's economic mirrors have stolen our cultural mirrors. (1973)

Le Pornolithique (1993–94) is an analysis of the master narrative of contemporary violence as seen on TV. In *Histoire(s) du cinéma*, Godard cites films generally to evoke the lost glory of the past. In *Images*, on the other hand, Lefebvre

cites films largely to illustrate the violence endemic to American genres.

The most insistently political of this series, *Le Pornolithique* consists almost entirely of images captured from a television screen, with the exception of one recurring shot directly taped by Lefebvre. The essay asks, What representations form the visual habitat of our lives? What images, through the environment of television, are constantly available to the eyes of children? The answers are terrifying.

The video opens with a dedication to the memory of Gilles Groulx, the filmmaker whose *Le Chat dans le sac* in 1964 confirmed the sense of an emerging national cinema in Quebec. *Le Pornolithique* then fades in on the one image not derived from television—a big close-up of a baby's eyes. These eyes belong to Samuel, Lefebvre's youngest child. They will return throughout the essay, partly as punctuation, partly as imploration. While the sound of surf affects our ears, the image shifts to a video recreation of the origins of cosmological time, and Lefebvre offers a lesson in cultural evolution. Beginning with the Palaeolithic age, he tells us, we passed through the Mesolithic and the Neolithic into the ages of copper, bronze and iron. We now inhabit the Pornolithic age—the Age of Images.

Shots of chase scenes from a Western, the images aggravated by slashes of red, accompany the final words of the opening commentary; and after the titles, the video opens out into an extended American wrestling match, an exhibition so virulently racist that the Québécois commentators can scarcely believe what they are seeing.

It is December 1990, close to the time of the Gulf War—really the systematic bombing of Iraqis to get them out of Kuwait. In the ring, in a tag-match of violence and racial hatred, an American team is pitted against what appears to be an Iraqi team. Then another American enters the ring, carrying a club. He rails against any foreign threat to the American people as the crowd goes wild. Finally, he leads the crowd of largely young people in cheering "USA, USA" over and over again.

Wrestling is theatre, as we know—a comedy of rehearsed brutality. Ideally, it might serve as a culturally endorsed displacement of racial intolerance—an encapsulation of the violence of Desert Storm. But this sequence is disturbing both in the degree of its unthinking intolerance and in the mindless acceptance of the cheering crowd.

In the next sequence a young woman appears, and tearfully recounts the violence of Iraqi soldiers, describing how they threw babies from their incubators onto the floor. More chase scenes follow, still with slashes of red, now intercut with war footage of even greater violence, portrayed as if war were a video game. "Rock 'n' roll!" one American jet pilot exclaims as he sets off on his mission to purify the world. The sequence ends with a voice-over of an announcer reading a newsflash of the actual Desert Storm, informing us that the Iraqis are withdrawing from Kuwait, while baby Samuel's eyes look out at us again.

Such a visual collage annihilates distinctions between fiction and reality. As the images speak to one another from their different representational spaces, they become products of the entertainment industry—part of what North American television offers as distraction from the world.

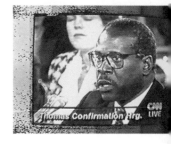

The video continues with its collage of violence, passing through gangster films, Nintendo games, more racist wrestling, violent cartoons, a TV evangelist, racing cars and terminators strutting their terminating stuff. Every so often we see Samuel's eyes. Although the shot is the same, increasingly the eyes seem terrified, as if they too are seeing what we see.

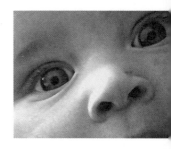

After a sequence of the Clarence Thomas/Anita Hill sexual harassment hearings, with the black-and-white image framed by colour bars, we witness the news reports and the security video showing the abduction of Jamie Bulger—the young boy from Liverpool who was murdered by two ten-year-olds in 1993. Now when we cut to Samuel's eyes, the image is negative. This deed has diminished hope.

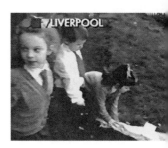

Next we see a newsreel sequence on the mismanaged violence at Waco, Texas, intercut with moments of domestic brutality, a sex scene and savage shots from disaster

movies. The video continues to blur all distinctions between the fictional and the real. As if to lighten the tone, we see shots of the mechanical soldiers of *Babes in Toyland*—the Laurel and Hardy classic of 1934. But when intercut with war footage, whether from newsreels or fiction films, *Babes in Toyland* takes on an increasingly sinister appearance.

Le Pornolithique ends with a final reference to Jamie Bulger, citing one judge's suggestion that the young murderers might have been influenced by violent videos. The final cut to Samuel's eyes now shows them cast downwards. As he raises them and looks out at us one final time, the effect is electric. What kind of fear do these eyes contain? What kind of plea are they making? These are the questions that Lefebvre leaves us with at the end of this essay.

L'Écran invisible

What exactly is it—*a territory*? A place favouring birth, growth and a continuing life; a place where life can be lived in solitude or with others, in all its forms: biological, spiritual, emotional and cultural. (2000)

Marthe Nadeau appeared in four films by Jean Pierre Lefebvre. Along with J.-Léo Gagnon, she shares the leading role in *Les Dernières Fiançailles*, one of Lefebvre's most celebrated achievements. Over the years she became, as Lefebvre has confessed, a second mother to him. *L'Écran invisible* (1994) is dedicated to her memory.

If *Le Pornolithique* is the most political of this series, *L'Écran invisible* is the most personal. It is also the most poetic. The sound of waves on a beach

again reaches our ears as the image shutters open onto cedar tiles on the side of a barn, with the shadows of leaves fluttering across them. After several dissolves through this texture of light and shadow, the camera zooms in on another wall to a window, which becomes a screen as the opening title appears.

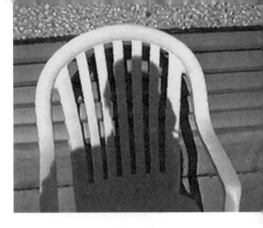

We see Samuel, a little older now, in a bunny costume; a shot from an airplane and one of a winter park; then the camera takes us to a hotel room. This time it zooms back from a window, which also becomes a screen. In voice-over, Lefebvre asks us to take a seat while he searches about in the storehouse of memory for whatever is left behind in "the silence of shadows and the music of light."

A sequence of family scenes and images from nature follows. When the camera returns to the interior of the hotel room, Lefebvre, still unseen, narrates the story of a film he had thought of making, the story of someone who one morning, after kissing his wife and children, set off for work, bought some flowers for his employees, entered just such a hotel room and fired two bullets into his head. As the camera moves in on a pillow on the bed, Lefebvre explains that "I could have been that man. You could have been his wife, his children or his employees." But Lefebvre isn't telling *that* story, he disarmingly explains. He wants the images to look at us, as he puts it, and in turn we may reflect upon them.

If *Le Pornolithique* is informed by images of violence, *L'Écran invisible* is informed by images of family—both Lefebvre's former family, when he was a son, and his current family, now that he is a father. Shots of that empty hotel room, with chairs waiting to be sat in, beds to be slept in, and spaces to be filled recur throughout the film.

As delicately suggestive as anything Lefebvre has done, *L'Écran invisible* is about potential. More elusive in their associations than in *Le*

Pornolithique, the images in this work frequently involve travel—on planes, trains and boats—bestowing on the video a sense of quest.

But there are tensions. There is an occasional scene of two women in a pub, the bottles of beer beside them on the table. Although without speech, these moments suggest distress. Perhaps one of the women is a friend of the man who killed himself in the tale that might have been told. Perhaps not. Like Lefebvre's story of a distressed Native woman, who is described but not seen, this pub scene reminds us of the existence of unhappiness, even in this work that is searching for the sun.

There is, however, a sly narrative within the essay. Sometimes, in among the shadows and light, we see the shadow of Lefebvre with his camera, photographing light. There is also a recurring shot, unexplained, of a patio chair, out of focus, shot through rain. Just before the end of the video, however, outside in the sun, Lefebvre's camera approaches the chair and fills it with his shadow. The effect is orgasmic. In this essay-poem without a story—or with many stories—a narrative climax has been achieved. Absence has been filled with presence although that presence is just a shadow. Nothing has been specified. Spectators must imagine what is going on. We must participate (as academics say) in the construction of meaning.

Perhaps as part of this story or as part of another story, there are incidents implied within the hotel. We keep returning to that room—or another just like it—sometimes inflected by sounds of occupancy. At one moment, however, the bed has been slept in. Something has occurred. Like the musical motif, sometimes hummed, sometimes played on a piano, that reinforces the musical structure of this work, the empty images of the hotel room release the full force of our imaginations. More is suggested than could possibly be shown.

In *Yokihi* (1955) by Kenji Mizoguchi, when Princess Yang Kwei Fei walks out of frame towards her execution by hanging,

her abandoned slippers and necklace on the ground evoke the event that we have no need to see. So in *L'Écran invisible*, a single match in an ashtray, an unruffled pillow or a phone that doesn't ring suggest the solitude that might have been part of the suicide story, and later on the slept-in bed evokes a possibly happier story, also left untold. These metonyms possess a potential beyond the reach of any dramatized representation.

If sounds of water opened *Le Pornolithique* only to be repeatedly extinguished by images of fire, a sense of water pervades *L'Écran invisible*. As in *Mon amie Pierrette*, images of summer shores abound—whether in Prince Edward Island or at Lac du Cerf in Quebec. And during a beautiful scene in the St. Lawrence River, we see Lefebvre's wife and daughters swimming in synchrony with beluga whales.

The penultimate moment of *L'Écran invisible* is a still shot of the moon through trees. The culmination of the many scenes of nature that have occurred throughout this work, it is reminiscent of an early moment in that classic celebration of Québécois space, Pierre Perrault's *Pour la suite du monde*. It also has the formality of a Group of Seven painting. We then cut to a shot of the barn that opened this video. The image shutters down and the essay is over.

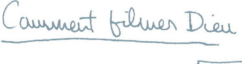

Comment filmer Dieu

I believe that culture is what will remain once Economism has completely sterilized all human activities, religion as well as the arts. (1999)

Over a black circle on a blue background, as in *La Pornolithique* as if at the beginning of time and once again to the sound of surf breaking on a shore,

we read a poem about a dream—a dream that human civilization has never existed. The last verse explains:

> *Earth*
> *has no image of itself*
> *it was*
> *is*
> *will be*

Comment filmer Dieu (1994) investigates the images that civilization has designed for us, both in the movies and in our cities. The chosen movies are the biblical epics of Cecil B. De Mille. The chosen city is Toronto.

After the poem, the film intercuts black-and-white scenes of a lion pacing in a cage with colour ones of Jean Pierre, our guide for this inquiry, walking about in Toronto's Chinatown. While he pauses to consider, the lion peers through a red peephole in his black-and-white cage.

What he sees is the sexual climax, *circa* 1949, of De Mille's *Samson and Delilah*. Victor Mature is battling a lion, wrestling its mighty strength, eventually breaking its neck. Hedy Lamarr looks on with aroused admiration. Then there is a shot of a large rock by a shoreline, some totem poles and the rock sculptures that form part of the campus of Ryerson University.

These images are followed by a shot inside the university and a photograph of a woman posing beside a huge figure of a mythical beast, before we cut to Jean Pierre addressing us from a bus shelter. "How do you film God?" he asks; but he is quickly pulled away by the violence of the city.

Sirens squeal, an ambulance rushes by, followed by a fire engine. Feigning excitement, Lefebvre invites Lionel Simmons, his cameraman, to follow the noise. "Maybe we'll be able to film something that will make us mil-

lionaires," he exclaims. "It's like Hollywood. I hope there'll be some dead and wounded, some blood!"

Back in his bus shelter, Jean Pierre explains the purpose of this study. The noise is appropriate, he suggests, since urban noise is about the same age as cinema. He wants to take us on the most important quest that man has ever undertaken since "he has been able to represent reality that is similar to dreams and dreams that are similar to reality." We cut to Charlton Heston as Moses, his arms outstretched, larger than life, parting the Red Sea in *The Ten Commandments*.

A cut to baby Samuel, naked, scurrying along the floor in Lefebvre's country home, brings us back to earth. The following montage, largely in black and white, of wooded scenes in winter intercut with children's drawings establishes the equivalence that exists between the actualities of nature and the scribbled images of children. Culture, as Lefebvre has argued, owes its origins to primordial needs. In order imaginatively to inhabit a given space, people mark their boundaries with signs. They need to establish a language that defines them as a culture. If this remains a pressing concern for the Québécois, a need now largely unacknowledged, it is also arguably a need for everyone, everywhere in the world.

Comment filmer Dieu pursues this investigation by comparing the architectural markers of the city, their value diminished by ubiquitous noise, with a low-budget feature being shot in Toronto. In this way, the big is counterbalanced with the small, the big "professional" city with a small "amateur" film.

Throughout its fifty-one minutes, *Comment filmer Dieu* addresses the results of the denaturing of nature. We see wooden flowers in a lawn and metallic sculptures of cattle, while the Voice of God from *The Ten Commandments* rails against all graven images. Waterfalls and wooded vistas reside

inside hotels but the pastoral tranquillity of Toronto's waterfront is deformed by the roar of aircraft landing and taking off. Sitting outside on the deck of the Toronto Island ferry, Jean Pierre examines what these accelerations have done to our sense of time. We rush about to save time, to *kill* time—an expression he deplores because if there is anything precious in life, it is time. If God exists, Jean Pierre suggests, perhaps God is time.

Throughout these face-to-camera discussions, Lefebvre returns to walking shots through nature, in different seasons, over different periods of time. These shots are intercut with children's drawings, suggesting an alternative to the denaturalized imagery of Toronto and, once again, a direct relationship between the natural world and the initial gestures of children. Towards the end of the video, he also intercuts two sequences of himself walking about the city, one in a jacket, the other in a T-shirt—thus implying a continuity over time of his thoughts about contemporary civilization.

"Time is money," he acknowledges in English; but can money be time? French is not the language of money, he suggests; but what language will we be speaking in a thousand years? What films will we be looking at in five thousand years? In 30,000 years, will an image be worth a thousand words? Or a thousand dollars? As always with Lefebvre, he is concerned with the survival of alternatives over time, with the vitality of culture; and as always, he is thinking about the culture of Quebec.

Earlier in the video Lefebvre interviewed Lionel Simmons, his cameraman, in a café, asking him how he would film God. Savouring his spritzer, Lionel says that first you would have to get out of Toronto. "God has taken the GO train to Scarborough," he concludes. "God knows what awaits him there!"

Later on, however, Bruno Pacheco, the director of the low-budget feature, is more serious. Initially taken aback by the question, finally he suggests that "to film God would be to film people believing in people, people believing in themselves." This statement provides a moral not only for the video but for the complete works of Jean Pierre Lefebvre.

For the end, Lefebvre returns to a shot of the lion in his cage at the Granby Zoo in the Eastern Townships, deprived of his natural habitat. When he seeks out the peephole again, he sees another moment from *The Ten Commandments*. Moses is now restoring the waters of the Red Sea to their

natural condition, allowing nature to return to itself. This return to nature also provides a moral for the complete works of Lefebvre.

Mon chien n'est pas mort

What I've wanted to insist upon and to apply to my films . . . is the right to adopt a small scale, to make films that don't claim to be absolute masterpieces. It's the right to continue to seek in a work what is above all a movement, a reflection. I reserve the right to make primitive films. (1990)

Supposedly a film about Kathy, a mongrel pup recently acquired at the request of Lefebvre's children, *Mon chien n'est pas mort* is actually about the creative imagination at its most defensive. If in all his work Lefebvre has been the master of the minimal, *My Dog Is Not Dead* is his most minimalist video.

At the antipodes from the violence of *Le Pornolithique*, intimately confessional in tone, it examines how a filmmaker functions when denied access to the tools of his trade. It is also, as he explains, an exercise in direct cinema—a style of documentary pioneered at the National Film Board; although he never practised it, Lefebvre considers direct cinema crucial in the early development of Québécois film.

The intimacy of this video is disarming. We hear Lefebvre clearing his throat, then excusing himself—thereby intensifying the impression he is talking directly to us, that we are privileged visitors in his home.

The water sounds that open this investigation are the sounds of a tub being filled in order to wash the dog. Water imagery recurs evocatively throughout these videos but here in *Mon chien n'est pas mort*, there is a humorous sense that, like Kathy reluctantly taking her bath, Lefebvre himself

has to get his feet wet, to dive in, to take the plunge—in French "se mettre dans le bain"—as we listen to the ongoing sound of splashing in a bath.

Five years have passed since his last feature—*Le Fabuleux Voyage de l'Ange*, a film that was most aggressively rejected by the critics. He is waiting for a chance to make another, which will eventually become *Aujourd'hui ou jamais*. Meanwhile, as an image maker, he wants to work with images. He is making this video, supposedly about his dog, not to kill time—a concept that, as noted earlier, Lefebvre considers atrocious—but to *live* it. He has some notes but no real ideas—as in direct cinema. He doesn't want to be the master of what he is filming.

While he is talking about his plans, scenes of family life abound. Although his daughters are sometimes in the shot, young Samuel is once again the privileged player. These scenes are mostly in black and white, and always in widescreen format. They are magically beautiful, conveying the values of home and family that counterbalance the production difficulties that Lefebvre must now endure. As he is talking about the pleasure involved in hiding behind a screen, whether large or small, and looking at people who are looking back at you, Kathy is outside the house moving from little window to little window, nose to nose with Ziggy, the older dog, who is on the inside looking out.

The arguments of this film are too numerous to summarize. A few examples must suffice. Playing with the ideas of René Descartes, Lefebvre declares: "I film my dog, therefore I think, therefore I am." Furthermore, if he makes an image of his dog, then the dog exists in her own image. These comments, both serious and playful, lead to the final declaration of his position: "When all is said and done, I am incapable of ever being or becoming an institution."

This declaration underlines the dilemma of Lefebvre as a filmmaker. In this age of globalization, the Canadian funding agencies, whether federal or provincial, deal only with institutions and even then only with institutions that have a track record of financial success. Many voices have

been silenced—Jacques Leduc, Jean Chabot, Paule Baillargeon, Micheline Lanctôt—while others have adopted a supercilious cynicism such as we now find in the work of Denys Arcand.

Lefebvre cannot function in such an environment. But that is okay, he explains: working with the simplest of video equipment allows him to play with images in the way Félix Leclerc or Georges Brassens could play their guitars. In terms of theatrical production, however, he is not optimistic.

The second half of this work abandons the black-and-white widescreen format and takes us for a walk in the fields with Samuel and the dog. It is a cut back in time—undoubtedly the footage first shot for this video. The season now is autumn—the time of Hallowe'en. In style, it is much less formal than the opening section. It is very much a home movie.

Odd tensions occur. First of all, Samuel speaks English while Lefebvre speaks French. Secondly, Samuel resents the camera, wanting his father to play with him in the fields. About Samuel's persistent petulance, Lefebvre declares: "There you have it—a little episode, quite commonplace, in the life of a child similar to all children nowadays who watch television."

In his role as a father, Lefebvre is largely absent from this episode, as he was in *L'Écran invisible*; again he is present as a shadow, following Samuel about and registering his antics with the dog. Meanwhile, when not responding to his son, his voice speculates about the economics of filmmaking in Quebec; why, he wonders, when Hollywood entertains us so well, do Canadian funding agencies invest so much money in an indigenous entertainment industry? If an amateur video that was racist and scatological could close down an entire paratroop division at the army base in Petawawa, Ontario, why, Lefebvre asks, don't people demand that the major film

studios be closed down too, since they make violent war films that are equally racist and scatological?

If we are feeling by now that, in spite of Lefebvre's observations, the images of Samuel and the dog are increasingly banal, Lefebvre is ready for us. Citing writer Fernand Pouillon in *Les Pierres sauvages*, he explains: "Reality is banal except for the pleasure of bringing it to life—*de la faire naître*." It is the game of observing life, the act of recreating its exactitude, that endows it with significance.

As if to remind himself once again of his theatrical defeat, he ends with the same song that ended *Le Fabuleux Voyage de l'Ange*. With music by Daniel Lavoie and lyrics by Lefebvre, it celebrates feelings close to his heart:

> You're going on a journey
> Life your only luggage
> Follow the route of tenderness
> Against hate, against distress . . .
> You're going on a journey.

For all the difficulties of his situation, Lefebvre still believes in the values of compassion that must guide one throughout the voyage of life.

La Passion de l'innocence

To make the spectator the creator. That, for someone who's always been present at the unfolding of his own story, watching but not participating, is a poetic necessity (which of course also includes politics). (1968)

The four video essays explore the process of image production. From the pornography of television to the banality of a home movie, Lefebvre invites us to consider the signs that are among us. With the exception of *L'Écran invisible*, the elusiveness of which lends to it the connotations of fiction, these essays are investigations. They are visual lectures—disquisitions upon the images that are part of contemporary consciousness.

In *La Passion de l'innocence*, however, Lefebvre is less investigating than presenting. With the active participation of his cast and crew, he is creating. And with extraordinary delicacy, he is creating images that refer to other images, planes of reality that intersect with other planes of reality. *La Passion de l'innocence* is as fine a fictional feature as Lefebvre has ever made.

A simple film, a domestic film, it is a video-film about a wished-for film. Since both the video-film and the wished-for film have the same title, distinctions between them are initially difficult to discern. This difficulty is central to Lefebvre's aesthetic. As in *L'Écran invisible*, the meaning of the film becomes the meaning we create for ourselves in the process of experiencing it.

The story is commonplace—an everyday tale about an everyday woman who works as a waitress but wants to be an actress. She hopes to be cast in a film called *La Passion de l'innocence*. As portrayed by Liane Simard, Michèle is a woman uncertain of herself who longs to play Marjo, a fictional character who is more self-assured. The video-film begins with a screen test. Michèle, garishly lit, is awkwardly posed against a wall, exchanging lines with the man who will play Paul (Widemir Normil), her black lover in the wished-for film.

This is how the industry works, Lefebvre is suggesting, because he would never treat his cast in so impersonal a manner. A drive into Montreal from we don't know where moves from night to day and recapitulates on the radio news the violent world of *Le Pornolithique*. We move up the empty stairway into Michèle's second-storey apartment, where we watch her waking up in the morning and feeding her cat. These scenes are inter-

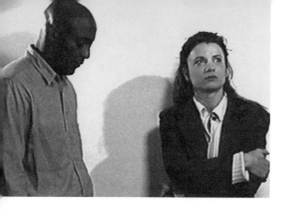

cut with images from the screen test, which flash us forward to different moments in the wished-for film. As we will later realize, at the beginning of this video-film the two actors are actually rehearsing their scene of separation, which takes place at the end of the wished-for film.

These temporal dislocations destabilize our sense of time. Are the screen tests memories or anticipations? And what are we to make of the black-and-white dramatic sequences that make up a substantial part of this video-film, because the wished-for film we are watching cannot, in narrative logic, have yet been made? *La Passion de l'innocence* teases us by confounding different planes of cinematic representation, perhaps suggesting—as in *Mon chien n'est pas mort*—that imaginative transformations are as important as reality itself.

Like all of Lefebvre's work, this video-film is full of *longueurs*—quiet, slow moments of contemplation that invite participation by the audience. We frequently see Michèle alone in her apartment. Although she says nothing, she is always reacting—sometimes to something said, as when she listens to her lover's tape—but generally just to her own thoughts. Lefebvre and his team pass on to us the responsibility of imagining what these thoughts might be.

A pure example of this strategy occurs with Michèle's sister, Pauline (Geneviève Langlois), travelling on the métro. When we first see her, we don't know who she is. As we look at Pauline looking at nothing in particular, her expression passes from obvious concern, as if experiencing distress, through the gradual broadening of a smile into quiet laughter, perhaps from a story remembered or from some inner reconciliation with her grief. When other people enter the carriage, her expression returns to neutral, to just being alive in the world on a train.

Whatever her inner thoughts, when we later learn that she is HIV positive, we may feel we have gained a retrospective understanding. But not necessarily. Furthermore, in its passage from anxiety to acceptance, Pauline's scene in the métro encapsulates the emotional trajectory that Michèle

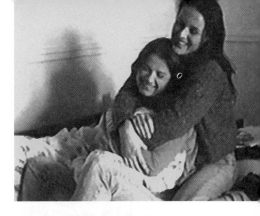

will follow throughout the course of the video-film.

Both sisters have a difficult relationship with their mother, their arguments with her always taking place on the telephone. The mother is never heard nor does she appear. Nor does Renaud, Michèle's *chum* now in Calgary, although we hear his voice on tape. The repeated separation of sound from image restores to this video the magical evocations of silent cinema, of the joy simply of observing what is there. Furthermore, the *reactive* acting gives the film an immense interiority, as our creative imaginations must supply to these moments what is left unsaid.

The love scenes in the wished-for film, all shot in widescreen black and white, are delicately handled. Her white fingers intertwined with his black ones, his wedding band on display, convey the intimacy that they feel for one another as well as the reasons why the relationship cannot continue. He cannot leave his wife.

Another extraordinary scene involves an orange, a phone call, and Carnaval, the cat who, according to the credits, helped to write this film.

While Michèle is eating an orange, spitting out the pits, a phone call informs her that she didn't get the part, somewhat contesting the "reality" of the wished-for film that we ourselves have been "really" experiencing. She continues eating her orange, piling the rinds on the antenna of her cordless phone before flipping them on the floor for Carnaval to play with.

The scene recalls that celebrated moment in Vittorio De Sica's *Umberto D* (1952) when the maid gets up in the morning, grinds the coffee, and gets ready for the day, while a cat walks along the glazed roof above her head. In the 1950s, this scene conferred upon cinema a sense of natural time and (if you like) an almost mystical intensity of observation. Although it had nothing to do with the plot, it had everything to do with the world in which the plot was taking place.

So it is in the films of Jean Pierre Lefebvre. None of these moments in *La Passion de l'innocence* have anything to do with the plot, largely because, outside the wished-for film, there isn't one! The temporal dislocations, the shifts in planes of reality, those wonderful speechless moments of sustained reaction uncouple this film from any narrative dependence on cause and effect. A cinema of action has become a cinema of seeing.

If these speechless moments pay tribute to De Sica and, by extension, to silent cinema, the end of the film pays tribute to Gilles Groulx, to the memory of whom Lefebvre dedicated *Le Pornolithique*. As in the penultimate scene of *Le Chat dans le sac* when Barbara (Ulrich) is putting on her make-up and talking to herself in the mirror, in the penultimate scene of *La Passion de l'innocence*, Michèle too is talking to herself in the mirror, but her reflection is Marjo—the character she has wanted to be. When Michèle asks permission to wear Marjo's clothes, the clothes we saw her wearing in the wished-for film, Marjo assures her that she can borrow her character as well. If Michèle has the ability to *imagine* the character, she can *become* that character. Michèle's mirror reflection explains:

> You're the one who decides that you have the strength to love, the strength to be who you want to be, and the strength to throw yourself into life.

Empowered to achieve the strength of the character she wanted to play in the wished-for film, she sets off for the site of her scenes with Paul, her imaginary lover in the wished-for film. Now her winding staircase is full as we follow her down it; and now these sites that we have seen before in her black-and-white world are in colour.

She returns to the amphitheatre in Parc le Provost in the north of Montreal where she had enacted (or imagined) her scenes with Paul. She stands in the centre as the camera circles around her, as it had circled around the departing lovers in the wished-for film. But instead of an imagined grief, she now experiences acceptance. When she sits on the bench, we experience the same play of emotions we had witnessed with Pauline in the métro. Her face moves from thoughtfulness into a broad smile of self-acceptance, now freed from fear.

The final titles are intercut with more scenes from the opening screen test, as if to remind us that we have just participated in an intricate game of cinematic representation. Narratively, the film ends where it began.

Epilogue

The provincial government does not understand any better than the federal government what is at stake ideologically in allowing our cinemas and our television channels to be flooded with American films and programs. They do not seem to understand the ideology of cultural production. (1981)

The world has changed a great deal since the 1960s and 1970s when the films of Jean Pierre Lefebvre enjoyed a quiet but steady critical acclaim. Given their ascetic formality, their conceptual simplicity and the creative responsibility they bestow upon spectators, the image productions of Jean Pierre Lefebvre inevitably receive a specialized attention. This specialization, however, may have more to do with gatekeepers than with audiences. In its directness, his work can have a strong emotional appeal for all kinds of people, when they are allowed to see it.

In the past thirty years, however, many idealisms have been abandoned, as if in defeat. This silencing of alternative voices is taking place everywhere, even in pockets of the United States. But in Canada, the more voices are silenced, the more American voices are heard. Back in the 1960s in an interview in *Cahiers du cinéma*, Lefebvre declared that either the Canadian cinema would survive "or we will become Americans." In film, becoming

American is increasingly not only the most lucrative but apparently the only acceptable goal.

Is it possible to regain the promise of the 1960s? For the Québécois it would seem to be a necessity. In 1980, in an article reprinted in Susan Barrowclough's monograph on Lefebvre, André Pâquet wrote that "A country which existed only in our imaginations became, through our films, the imagination of our country." Does that situation still exist? Can it exist again?

Perhaps the role of cultural definition has passed to television. Whether in "prestigious" shows like *Les Filles de Caleb* (1990) or "vulgar" serials like *La Petite Vie*, television has become the primary outlet for Québécois voices. Even Quebec song has moved away from the passionate celebrations of Gilles Vigneault to the international accomplishments of Céline Dion, singing her heart out at the Academy Awards.

If an air of melancholy hovers over the recent film work of Jean Pierre Lefebvre, melancholy also lurks within the psyche of the entire generation of the 1960s that once felt a new hope for Quebec. As Lefebvre recently explained in his open letter to fellow filmmaker Michel Moreau, Quebec has passed with such speed from a religious age of incense to the financial age of investment that it has lost itself along the way.

Suggestions of melancholy, fatigue and *ressentiment* have long formed a part of cultural discourse in Quebec, as if in anticipation of the onerous burden of achieving a truly sovereign identity. In 1962, in the essay "The Cultural Fatigue of French Canada," the Québécois novelist, Hubert Aquin, declared that

> French Canadian culture shows all the symptoms of extreme fatigue, wanting both rest and strength at the same time, desiring both existential intensity and suicide, seeking both independence and dependency.

His might have been the story that was withheld by Lefebvre in *L'Écran invisible*. At least in part because of political despair, Aquin committed suicide in 1977.

Citing a galaxy of psychoanalytical thinkers in an article reprinted in *CineAction* 16 in 1989, Denis Bellemare has suggested that the emphasis

placed on the banal details of everyday life that one finds in direct cinema is a way of dealing with melancholia—of repressing resentment, of deflecting one's inner anger.

> The banal, a force of inertia, so sustains repression that one wonders if this is not a particular response that the melancholic ego has adopted to rid itself of excess destructive energy.

This discourse does not *explain* the work of Jean Pierre Lefebvre. It does, however, suggest an approach to the problem of cultural colonization within which, in a more extended study, Lefebvre's work might play a part.

As his many articles attest, however, Lefebvre does not repress his anger or despair. Railing against the inadequacies of cultural policy in *Cinéma Québec* in 1977, Lefebvre complained that

> ... what we're being offered—and by we I mean the ordinary people along with the filmmakers/craftspeople/citizens—are the same coloured beads, the same bits of broken mirror that signalled the beginning of the systematic massacre of our Native brothers.

For over thirty years, Lefebvre has argued for a cultural policy that would help the Québécois resist the Americanization of their imaginations. He could have been arguing for other Canadians as well.

The American cinema provides the most seductive means of colonization the world has ever seen. Hollywood movies demand complete attention, generally involving a totality of audience identification. This process explains how colonization operates: while watching Hollywood movies, no alternative realities are available. Their closed structures decide everything in advance.

This is the entertainment ideology of a totalitarian state. But no one much cares, because so many people involved with film are making so much money. They inhabit a comfortable world, which they scarcely realize is a world without choice. Jubilant in its mediocrity, entertainment is now the opium of the affluent.

Resistance to this ideology explains the intricate structures of Lefebvre's finest work. His productions, finally, are profoundly philosophical. Although in every pore an artist, Lefebvre never talks about art. His cinematic innovations are not designed to create aesthetic thrills for the *cognoscenti* (although they have that effect): they are about empowering spectators, as he has explained, but they are also about the retrieval of time. Like the writings of the Canadian philosopher George Grant, especially in his *Time as History* (1969), Lefebvre's paratactic narratives contest the (largely American) notion of time as progress, of time as the pursuit of technological mastery. They contest a utilitarian concept of time.

For Lefebvre, time is *not* progress. Time is *not* money. As Henri Bergson insisted in *Creative Evolution* almost a century ago: "Time is invention or it is nothing at all." Lefebvre is interested in time as experience, as reflection, as room for the contemplation necessary to experience the wonder of the world and to transform its banalities through one's creative imagination.

Again like Godard, Lefebvre has wanted to achieve a *fully adult* cinema, a cinema as maturely thoughtful as the finest paintings or novels. For Lefebvre, as he has said in *Comment filmer Dieu*, time is sacred. Perhaps God *is* time.

In today's world of accelerated excitements, the image productions of Jean Pierre Lefebvre are (in today's parlance) uncool. They are *engagés*. They are about values. They are deeply committed to the process of life. Refusing audience identification, they request participation. They are about caring. They involve thought.

If they sometimes seem naïve, the films of Jean Pierre Lefebvre are not romantic. Unlike Godard who, like all great romantic modernists, is constantly afflicted by the loss of the past, Lefebvre, although often melancholy, is continually energized by the necessities of the future.

The liturgical rhythms of Lefebvre's pastoral landscapes suggest a Native sensibility. Although he attributes his moral values to the example of his

La Chambre blanche

parents, his films are informed throughout by a Pauline sense of *caritas*—charity, compassion, human love. And if the water imagery that is present in so much of Lefebvre and which permeates the videos acquires a baptismal suggestiveness, these associations probably owe less to the church than to the many bodies of water that punctuate the Canadian landscape—especially, for the Québécois, the mighty St. Lawrence River.

Like Robert Flaherty, like the Italian Neo-Realists, Lefebvre is deeply committed to the sustaining relationship that exists between people and their environment. Thinking of William Wordsworth or Robert Frost, who are often described as rural poets, one might describe Lefebvre as a rural filmmaker. But that would be too simple.

As the dyadic structure of *La Chambre blanche* illustrates, there must always be a dialogue between city and country, male and female, political and pastoral, political and personal, winter and summer. These primordial rhythms, endemic to the Québécois, are ignored at one's peril. Certainly in Lefebvre's world, they provide a necessary nourishment for the human spirit, a nourishment that must inform that overriding dyad in all of Lefebvre's work that exists between culture and life.

In Lefebvre's vision, for Quebec to survive the commodifications of today's market mentality, people must know their past, must understand who they are and the spaces in which they live. This is the lesson that Michèle had to learn in *La Passion de l'innocence*. With the help of Marjo, her projected reflection, she was able to accept herself and to imagine the strength necessary to achieve a meaningful life. This process is essential, Lefebvre implies, for all Québécois. In conclusion, I would argue that a similar process is essential for all people who wish to achieve a sovereign identity for their own imaginations anywhere in the world.

Peter Harcourt

A Conversation with Jean Pierre Lefebvre

On 3 May 2001, I travelled from my home in Ottawa to Montreal to talk with Jean Pierre Lefebvre. He drove up from his country home in the Eastern Townships, and we met at Concordia University, where he now offers a course on contemporary Québécois cinema.

Lefebvre and I have known one another for more than twenty years, and we talked about many things, especially about the changes in Quebec society over the decades. I cannot convey in a transcript the physical animation of Jean Pierre in conversation, nor the Tex Avery sound effects with which he punctuates his statements. For Jean Pierre, everything is a joy. Everything is a game, as it is with children.

With Barbara Easto, his wife and partner, he has had three children— Simone, Julia and Samuel. For Lefebvre, there is no separation between his work and his life or his life and his culture. The domestic dimension of his personal culture and his work as a teacher both explain, in part, the genesis of his videos. I asked him how he became interested in the medium.

I first got interested in video while directing workshops. Twenty years ago we had big ¾" cameras—which were useless, because they were so heavy. They took an hour to set up, which didn't allow us time to experiment very

much. But as soon as I saw those little 8mm cameras I asked to have them, so that people could do a lot in a workshop, and not have to bother with a tripod or things like that. They were wonderful for directing workshops, although I never expected that they would upgrade the quality to Hi8 so quickly and to such an extraordinary degree.

I bought my first Hi8 camera in 1990. At the same time, in 1991, *Le Fabuleux Voyage de l'Ange* was a total disaster. I was demolished, trashed, like I'd never been in my life. I was dead on the ground. There was no way I could do another film. And I was demoralized as well. Who wouldn't be?

But I had that camera, which for me was a new toy, and that's very important because I love toys. I really believed there was something I could get out of it. I didn't know at all what it was going to be. So I did what I told my students to do in the workshops: I filmed anything, with no conscious plan, with no particular reason.

It's really fun to film that way. Once, after a week's workshop we screened what the students had shot, and we realized that one guy was shooting only trees or only posters, and another one only close-ups or long shots. There's an instinctual level of language in film that we don't often have the chance to experience any more. We don't let ourselves fool around enough because everything has to be efficient.

How did you get started on the four video essays and video feature that make up L'Âge des images?

The spark for the whole project came from the Clarence Thomas/Anita Hill hearings. I was in Vancouver showing *Le Fabuleux Voyage de l'Ange*. I was alone in my hotel room and bored as hell. So when those hearings came on TV, I started shooting it, right off the screen, not knowing at all what I was going to do with it.

I was travelling a lot in those days, giving workshops, and always trapped in dreary hotel rooms. So I started filming my hotel rooms. I accumulated a lot of material and let this material speak to me personally. At the same time I found some old 8mm movies of my family, which you see in *L'Écran invisible*; and all of a sudden, that became the key to *L'Écran invisible*.

As a project, I guess *Le Pornolithique* began with those wrestling scenes. They were broadcast in December and the Gulf War started in January. At that time in Quebec, the same program was shown in French from eleven to twelve and then in English from twelve to one each Saturday. I've always loved wrestling. It's like everything that's happening in the world: everything is scripted. So when the program came on I got my camera, and I knew I had some material to work with because that wrestling scene related to the Gulf War. So that was the beginning of *Le Pornolithique*.

What is the meaning of the title Le Pornolithique?

For me, pornography is a deviation from a natural function. For instance, it's pornographic to see police cars being blown up by the hundreds in films. You use a car to go from one place to another. That's their normal purpose. So that was the basic idea for *Le Pornolithique*. Then I started to collect more and more things from television.

I also tried to see things through the eyes of Sammy, my newborn baby. For instance, what if I were a Martian or a baby and I saw all those images? What would their influence be on my brain? Some people claim we get used to them and that they have no influence, but I'm not so sure. You'd have to be quite stupid to think that they have no influence at all.

At what point did you decide to use Samuel's eyes?

Right at the beginning. When I recorded that first wrestling match, he was four months old, and he was on the floor near the television. Right after that, I shot his eyes. I didn't know I was going to use that shot. I was just collecting—getting images of my kids.

But it was an inferno working on that film. After I'd done it I realized that I'd freed myself from all those images. I'd reorganized them my way. That's the trap of all the media: they organize everything for you. You have no power of choice. But just the way I edited the news on Jamie Bulger, the little boy who was killed, giving it more time, cutting out the sound and repeating the images, helped me to be able to live through it. And *then* I cried. When you see it on the news, you don't interpret it for yourself, you

don't really experience it. That's what I learned from *Le Pornolithique*.

How did you assemble the images for L'Écran invisible?

I don't know. Generally I just followed my instincts. I wasn't answerable to anybody. I didn't know what it was going to be. With *Le Pornolithique* I had to structure something very precise. I knew it could be structured more easily than *L'Écran invisible*; but *L'Écran invisible* was simply feelings. I'd put one shot there and if it didn't work I'd start over again.

Where did you find those two women in the pub?

I shot the women one day when I went with some students to Hull. My camera was on the table and I saw the two women and the light was nice, so I pressed the button and that was it. Something fascinated me about those two women, I don't know what. It was as if they were telling a story that we couldn't hear.

Like the story of the suicide, which you decided not to tell.

Exactly.

What was the genesis of Comment filmer Dieu? *Was your friend Lionel Simmons involved from the beginning?*

I'd come to Toronto to act in *The City of Dark*, a low-budget film by Bruno Pacheco. I was staying at Lionel's, and the first day of shooting, the truck with all the props got stolen. We had to wait almost twenty-four hours with nothing to do. But we had the camera, so I said, okay, Lionel, let's go out and shoot a film! That's how it started. And we took advantage of everything.

It's funny, because when we were shooting at the Sheraton Hotel, the hotel staff was looking at us but they didn't disturb us. But afterwards, a Japanese crew arrived with a Betacam, and the hotel management wouldn't

let them film! So I discovered that, with those little Hi8 cameras you can shoot everywhere because they don't look professional. As soon as you have a Betacam, you're dead!

What is the purpose of all the water imagery in your next video, Mon chien n'est pas mort? *Why are there all the references to having a bath?*

It comes from the expression "se mettre dans le bain" in French which means to get going, to do something with your life, to dive in. A bit like in English, to get your feet wet.

Lefebvre's belief in the transformative powers of the creative imagination owes much to the writings of Henri Laborit, to works such as L'Homme imaginant *and* Éloge de la fuite. *I asked Jean Pierre about the quotation in* Mon chien n'est pas mort *from* Les Pierres sauvages *by Fernand Pouillon, about the necessity of transforming the banality of reality by the process of reproducing it.*

It's a clarion call for the creative imagination. If you don't recreate life, then nothing happens. Imagination is the symbolic interpretation of the world. It's as simple as that. And that's one thing we've lost completely. That's one thing, for instance, that the Catholic church destroyed when they arrived to colonize the country, forbidding the aboriginal people to have their gods. We have an explanation for everything right now, and that's what's wrong. There are a lot of things that we cannot explain.

Let's talk about the process of creating the video feature La Passion de l'innocence *and your interaction with the three main cast members, Liane Simard, Geneviève Langlois and Widemir Normil. I understand that you met the two actresses three years previously at the Summer Institute of Film and Television, which in those days was held at Algonquin College in Ottawa. What was it like working with them?*

When I met them in Ottawa, Liane was there as an actress and Geneviève was studying directing. Geneviève was there partly to exorcise her latest

love affair, and the character she created for Liane was based on herself. After a couple of days, they were like sisters. So close. It was wonderful to see them. And I also liked them very much.

Of course, the idea for *La Passion de l'innocence* came from what was *not* happening: I was waiting to shoot a feature film, waiting and waiting, and nothing was happening. So I transferred all my anxiety to the character of an actress waiting for a call: that was the idea for the video. She wants that role, and while she waits, she imagines how she will be in that role because it's the role of her life.

So I phoned Liane with that idea. I said that I'd made those four videos, that I wanted to go on experimenting in the same way. I wanted to be free. I didn't necessarily want to have a script and although I've never worked collectively with actors, I listen to them a lot and use every good idea they suggest. So I asked her if she was interested. Then when I mentioned Geneviève, she was really excited because they hadn't seen each other for ages, after that first meeting in Ottawa.

I started writing to Liane and she wrote back to me, telling me what the character must be thinking, or what she wanted to wear. The same process went on with Geneviève and with Widemir, who also wrote what he thought his character should be. So except for the screen test, which I wrote, everything was the creation of the actors.

For example, one of the most beautiful moments is that scene with the sisters on a sofa. We were sitting there with the camera and we knew the scene was going to be about the two sisters being together before one leaves. And when I asked them if they wanted to discuss it they said no, no, no: we know what to say and do. So everything in that scene comes from them. But of course, for six months we'd been discussing it and they'd known each other for three years. And I'd known them for three years. So it was total freedom for all of us.

There's only one shot where the camera's on a tripod, which is the main scene at the table. Otherwise, I wanted the camera to run about, to be able to do anything. And the actors knew that. The whole film was a series of miracles—because of the preparation. Everybody was totally without defences. It was all happening so easily. All the scenes in the apartment

were shot in sequence so we could pile up the situations as we went along.

I never know what to say when I have to direct a love scene. So for that scene I said to Liane and Widemir that it's important that we know there's been a strong physical attraction between the two of you. Try to find a way, I don't know how to do it. I don't care. But I want people to know that you've had a very deep sexual relationship.

But I do have an idea about how I'd like to film the scene, I explained. I'll use a smear effect, which happens when you lower the speed of the camera. It creates a flutter effect for the movement. It was all natural light in that film. When there was not enough light, we'd lower the speed. People don't believe us because it's all so beautiful. But there were no artificial lights in that film. When Liane and Widemir saw the effect of the slow speed on the monitor, they found it so beautiful that we filmed it that way.

What was the cost of La Passion de l'innocence?

Although the total cost was $76,000, we shot the whole film in four days with a grant of $26,000 from the Canada Council. I was allowed to go back for a post-production grant of about $15,000, but I didn't need to because I was able to shoot it for twenty-six thousand bucks.

Everybody was paid except for Barbara and me. The actors and crew were paid union fees. And we took our time. We probably worked about five or six hours a day. Usually there was only one take. Except for the scene in the mirror, because the first take was thirty-five minutes long! And it's totally Liane's improvisation. I had the idea of the mirror but she did everything else. She invented all the dialogue between herself and her character. And when you're shooting and you see those things happening, you wonder how it's possible. But again, it's because there were no restrictions. There was no one looking after the budget. If a scene was no good, we threw it away. Nobody would ever know about it. There were no walls, no barriers. And I learned once again how extraordinary it is to be creatively free. You're more responsible when you're totally free. The older I get, the more I let people do what they have to do.

What did you intend by the title, La Passion de l'innocence?

I love to do what I love with a lot of passion. But I love to keep my innocence as well, to retain my vulnerability. When you stop being vulnerable, you're dead. And that's what has disappeared from our films in Quebec: vulnerability. Up to *Les Ordres* and films like that, you could see the life in our films. They're full of generosity. When there's no life coming in, the films are dead. They're just cinema.

But you know, like the other essays, *La Passion de l'innocence* is still an abstract film. There's no psychology as such. For example, we talked about the reference to the little girl who killed herself and wondered whether we'd have to explain it. And I said no: that's just part of the mood of the film, part of the tension. Forget all the psychological aspects of the relationships.

Often, when I'm filming, I forget to say cut. I'm so moved I don't believe what's happening in front of my eyes. Like that final scene of separation between Widemir and Liane, in that wonderful dry pool in the circle. I couldn't believe what Widemir was doing at the end. It gave me something I didn't expect. So I cannot imagine working in a situation where everything's decided in advance.

What is the most crucial change that has taken place in Quebec over the past thirty years?

Indifference. Generally, people have become indifferent to what's happening outside in the world but even more to what's happening here. There is a lot of bitterness about the nationalist issue. It's taken up too much space, and a space that I think is wrong. There's a split between the politics, the culture, and life, if I can put it like that. What made the fifties and the sixties so fantastic was that everything was together. I'm not saying it was better. Simply that it happened that way. There was so much life in all Québécois films. We made films about social and political issues, not in intellectual terms, but as problems that were part of our lives, part of our future.

From the script of Les Dernières Fiançailles

début de la scène de thé

Armand fait une grimace, se réveille.
Puis il contemple ses horloges en souriant tendrement.
A ce moment Rose entre (par la droite) avec son cabaret.
Début, dans le mouvement de Rose, d'un lent travelling avant qui s'arrêtera quand les deux seront en plan moyen.
Rose: "Pis comment ça va mon vieux?"
Armand: "Ca va...ça va...J'su pas tuable, tu sé ben..."
Elle dépose le cabaret sur une petite table ronde à la gauche du fauteuil d'Armand.
Rose: "T'aimerais pas mieux que j'appelle le docteur?"
Armand: "Ben non, ben non."

8
Plan rapproché du cabaret.
La main de Rose s'empare de la poignée de la théière.
Elle remplit les deux tasses.

Rose verse le thé.
S'assoit.
Se lève imperceptiblement.
Prend son jonc de mariage dans la poche de son tablier.
Le passe à son doigt
Se relève.
Voit si le thé est bien bouillanté.
Remplit la tasse d'Armand et la lui remet.

Plan rapproché d'Armand à qui Rose donne une tasse.
Armand: "Merci."
Il ne boit pas tout de suite. Semble un peu absent.

Even in the sixties and the seventies, some people were telling me that I was making films that were too narrowly focused on Quebec. But that was what made them universal. My films have, in fact, been distributed throughout the world more than a lot of other Québécois films. Before *Le Déclin de l'empire américain*, which was the first big success, *Les Dernières Fiançailles* had been the first international success of *le cinéma canadien québécois*.

Now the mood is one of indifference and neutrality. Now to be a serious person here you have to make money, you have to know *how* to make money. The economists are playing the role the Catholic church used to play.

When I was doing my docudrama on Alfred Laliberté, we were shooting a little statue in the Musée des beaux-arts. A curator noticed how beautiful it was the way it was lit. He had never seen it that way. When we asked him why it wasn't always lit like that he explained that there's a rule in galleries that you cannot privilege one particular object over another. That's why you usually have neutral lighting.

For me, this is a good example of what culture has become in Quebec and in the world. In all this globalization, everything's supposed to be equal. Nobody wants to privilege one director or film over another. You can express your culture on the Internet, they say. That's like the dream they sold us in the sixties with pay-TV: it was supposed to be fantastic. The *cinéma d'auteur* was going to bloom. But it didn't happen. Money always works one way, it always drags everything behind its power, its need, and again its neutrality, which is never fair, and its indifference. In terms of money, of course, it's actually true: everybody *is* equal. Everybody is exploited. And you see that now in our own cinema, which is a fabricated commercial product.

Fortunately, independent cinema still exists, but it's more and more difficult, and even when fantastic films get made, they can't find any way of being shown. Télé-Québec does what it can, but it has so little money. For example, Télé-Québec is the only station that was interested in *La Passion de l'innocence*. It was shown three years ago and was a big success. And it was beautiful on television. I hate it when it's projected on a screen. It's not meant for that at all.

Given all these social changes, what arguments can you now make to the powers that be? Why should they support Québécois filmmaking?

The main thing that I've always fought for is continuity. I think that since we've been on this earth, what's made us at times a little bit different and even at times intelligent is continuity. We learn from what has been done before us. I've always dreamt that my kids would be less stupid than I am and that their kids would be less stupid than they are, and so on. What's very difficult here to face, to live, is the lack of continuity. I have no special right any more than other people to make films, but I do have some right to make them. And if I were the only one being treated like shit, I'd think that I was paranoid, or getting old, or that I'm no longer any good. But when I see other filmmakers being treated the same way, their projects being dismissed, I realize that we don't all speak the same language any more.

Fifteen years ago we believed in the *cinéma d'auteur*. The *cinéma d'auteur* has revived the English-Canadian cinema, with Egoyan, Mettler and the others. But in Quebec it's finished. People now ask who were those guys, Brault, Perrault, Groulx, Lefebvre, Carle? They're dead! Now the producers are selling merchandise and we've been assimilated. No other country has been assimilated so fast. We thought we were free, expressing ourselves; but we've been totally assimilated. This is the result of a lack of political will.

If the Canada Council didn't exist, the entire cinema culture would be dead. But there's something about the Canada Council that makes most people feel they're treated honestly. They see the cultural value in a lot of things that are presented to them. The Council respects people.

Since Aujourd'hui ou jamais, *you have submitted four scripts to the various funding agencies. Three have been turned down and another is on hold. How long can you go on writing scripts for films that don't get made?*

I'm not ready to become a full-time writer, because I'm not a writer, and because of that extra 40 percent that filmmaking gives me. In *La Passion de l'innocence*, the way we worked with Carnaval, the cat, is a wonderful example. We invaded his apartment but he adjusted perfectly to the new situation. He adopted Liane who was sleeping in his owner's bed. He had so

Passion et innocence

S'il y a une fable à raconter à propos de La Passion de l'innocence, c'est celle du chat Carnaval.

Il venait avec l'appartement loué à une jeune infirmière et a instantanément adopté Liane la comédienne qui occupait son espace à lui et celui de sa maîtresse.

Le rôle qu'il a spontanément joué, par instinct et empathie, ne se scénarise pas, à moins d'avoir beaucoup beaucoup d'argent ; mais dans ce cas on ferait performer les animaux à l'excès, les comédiens également, ne serait-ce que pour justifier la dépense.

Carnaval, lui, s'est contenté d'être chat à part entière. Avec passion et innocence.

Il a été notre modèle.

Jean Pierre Lefebvre

much empathy. When she was sad, he would come and look at her. He gave a wonderful performance. He was our role model. It was a little miracle.

But everything in that film was a miracle. After Liane received the phone call telling her that she didn't have the part, she sat down and started playing with the orange. I had control of the phone beside me. She was by the phone and Lionel was there with the camera. I could see that Carnaval was interested in those bits of orange rind. So I decided to make the phone ring and I said in my head that it's her mother phoning. When she heard the phone, she stopped, picked it up and said, "*Oui, maman. Je m'excuse pour tout à l'heure.*" Why does she decide it's her mother? It's just because it's in the air.

When you talk to me about imagination and spirituality, that's how I would refer to those ideas. You think of something you love and, suddenly, it becomes alive in your mouth. That for me is spiritual activity. I know I'm old-fashioned but when I see a film that feeds me with emotion and ideas I feel a much better person afterwards. It feels so good.

But I'm not sentimental about these matters. I think we have to adapt, to a certain extent. But I would like things to be a little fairer. I think it would be normal to recognize that there are some people who have done some things for the cinema here and, although they don't have priority, maybe they should at least be allowed to continue.

If we break all the threads that hold our culture together, there won't be any culture. I don't have the truth. Nobody has the truth. But we all have part of the puzzle. And if we cannot complete that puzzle, there's a problem. A problem of identification. This has nothing to do with nationalism. As a person you have to know who you are and be able to accept yourself. In Quebec, we were raised to love our neighbours but hate ourselves, to sacrifice ourselves. This is why I've felt the urge so much to speak, not just for myself but for others: for my mother, for my family. I still want to do that. And if my children were not around, I would totally give up. But I've survived because of Barbara and the kids. I have people to fight with and something to fight for and I've relearned life through my kids.

Jean Pierre Lefebvre

The Concept of National Cinema

This text is a condensed version of a lecture which I gave in Quebec City in 1986 at a conference of the Film Studies Association of Canada / Association canadienne d'études cinématographiques. I was surprised that Peter Harcourt asked me to have it translated and included in the present publication. I was afraid it was out of date. But I was even more surprised when I reread it: it is disturbingly up to date. *There was only one term,* l'économie inter- et multinationale, *which today I would render* mondialisation. – JPL, May 2001.

When it was suggested to me that I try to speak about the concept of national cinema, I accumulated so many notes that I soon found myself at an impasse. Was it a sign? I don't know. One thing is certain, the subject fascinates me as much subjectively, in that I am a contributor to the reality of a national Québécois cinema, as it does objectively, in that I am also an observer of the collective past, present and future of the society I inhabit. Despite that fascination, I fear I may never reach conclusions which are logical and solid . . . hermetic in other words, because often that which is logical, solid and rational is hermetic, leaving no room for life, chance or imagination.

Since the subject is so vast, constantly in a state of evolution, still in progress because Québécois cinema is only thirty years old, I essentially want to share with you a series of reflections. Forgive me for going against the strict rules of a commercial film script . . . obvious stories with photogenic conflicts. But as to conflicts, don't worry, there are plenty in what I am about to relate.

1

Beyond all doubt, the concept of a national creation, and a national cinema, is of great importance as it is linked to the notion of belonging, which is in turn linked to the instinct for survival. And creation—as I have often repeated—is one of the most spontaneous, necessary, direct and dynamic manifestations of that instinct. Let me explain.

We easily understand that for our physical survival we must find and share food. It is less easy for us to understand that we must also find and share the food of the mind, that is, *l'imaginaire*,[1] which has been the source of myth and legend since the dawn of history.

We could even claim that the human animal is born—was born, anyway—essentially a hunter *and* a creator. I say "was born" because things have changed over the centuries. But we carry within us, despite revolutions in industry and technology, the weight of thousands of years of human evolution. The proof lies in our children, those living fossils, who are spontaneous creators.

What is the meaning of spontaneous creation? Firstly, children scribble on walls or anything else at hand, to both touch and identify the Space around them and also to possess that space in a way. Secondly, when they have become more proficient, children begin to draw forms and representations of the fluctuating reality around them, which is Time: the sun and the moon, the seasons, the animals, the people—and the houses, lots of houses, because they are a child's spatial shelters against time. In very young children, these representations of time are, however, symbolic. A faithful rendering of forms doesn't come until later, usually when a child starts school, where the goal is to make culture fit into a mould (principally

words and numbers, the cornerstones of our civilization). It is at that moment, usually around ten years of age, when a child becomes truly conscious of the necessity of conforming to certain models, that the child ceases to be a spontaneous creator. Reason wins out over their instinct for survival and *l'imaginaire* becomes the slave of reality.

But no matter what, we can all say that our earliest childhood is strictly prehistoric and that we obey only the most universal laws of human nature. One of the most important of which is the influence of our environment, our individual perception of space and time. So African children do not spontaneously draw snowmen. And just as their environment determines the perceptions of children, so it is with nations. As a perfect example, we have only to make a comparative list of the different gods of the different Indian nations of North America. In fact, the concept of nationhood combines with our concept of our environment. A priori of course. A posteriori, the dictionary claims that a nation is "a human group, generally large, which is characterized by a consciousness of its unity and the will to live together." The word "consciousness" here may contradict the concept of nation as a natural perception of environment. We could even say that the consciousness of dominant nations is directly responsible for the upheaval and destruction of "natural nations" and of all they create from their environment.

Before going any further, let's sum up this way.

a) Originally, the concept of nation is natural and based on our perception of our environment.
b) Originally, creation is a direct and natural manifestation of the instinct to survive, which is also based on our perception of our environment.
c) Originally then, all creation is national, *tout imaginaire est national*.

But we are far from our origins . . . though maybe not that far when we speak of the cinema or the nation of Quebec, because what we refer to as Québécois cinema really originated in the sixties.

2

Let's return to the dictionary to know what the adjective national means: "1) that which belongs to a nation; 2) that which concerns an entire nation; 3) that which is managed, organized by the State; 4) that which represents, expresses a nation."

So a rational definition of national cinema might be: "that which derives from a given nation; represents, expresses and concerns that nation; and is managed, organized (or not) by the State."

I confess however that if someone asked me to make a "national" film according to that definition, I would be at a loss, as would be Telefilm Canada, SODEC, Radio-Canada/CBC, Télé-Québec, the Secretary of State... all the organizations involved in the national culture, or cultures, of Canada, and more specifically in cinema which, as Malraux wrote, is "also an industry."

Why? Why is everyone perplexed by the idea and the reality of a national cinema?

a) We can talk, a posteriori, about an indisputable national Québécois cinema whose deep roots grew out of the NFB in the mid-fifties. From documentary, to candid eye, to *cinéma direct*, to *cinéma-vérité*, to fiction, this Québécois cinema both reflected the transformation in our environment and actually contributed to that transformation. To the point that, after many misadventures and much pressure from the filmmakers themselves, the governments of Canada and Quebec came to consider our cinema as a national "product," worthy of financial and cultural investment. (Until then, cinema was considered a political and cultural tool, handy for influencing citizens of Canada and Quebec... just think of the NFB and the OFQ.)

This original national Québécois cinema also developed without concern for financial viability. Such concerns were not the business of the NFB. Meanwhile, in the private film industry, people were working on very tight budgets, often with huge deferrals of their salaries. Filmmaking was an exciting, crazy adventure.

But with the creation of the CFDC (Canadian Film Development Corporation, now Telefilm Canada) in 1967, and the Institut québécois du cinéma (now SODEC) in 1975, Canadian and Québécois cinemas[2] became

potentially rich. Also, the NFB threw itself into commercial cinema, playing by its own rules and not those of the private industry, which could not compete with the Board's financially supported "good" intentions.

And so the situation changed completely. We went from the natural to the rational, just as in Quebec we went from a natural, spontaneous nation to the desire to establish a rational political one. Until then, we had created as children do, for the pleasure of creating and the necessity of taking possession of our space and our time, our environment. And then we had to go to school, to confront the recognized models of creation, production, distribution and publicity (just as we had to do on a political level).

b) As a consequence, a political will was established, a priori, to make Québécois cinema international. (English-Canadian cinema meanwhile, which had no real national identity, had no problems copying the recognized forms of commercial cinema, to the point of importing many filmmakers from the USA to make sure the copies were as accurate as possible.)

But if there was a political will, and if there still is, it is a weak one. On the federal and on the provincial level we cannot (nor do we want to) upset the Canadian film market, which is in the hands of foreign companies or local businessmen (theatre owners, distributors, etc.) who make their money with foreign products. In fact, it is as if we had suddenly consented to give huge grants to the people who are already under foreign control, or to those foreign interests themselves. What's more, nothing has been done, not even in our state-run television in Quebec and Canada, to guarantee that the public has permanent access to our national cinemas.

So although created to help our national cinemas, political intervention actually put a knife to their throats, because no real economic base was given to our national film industry. I repeat, *national* industry. That is, an industry which would truly belong to our nation(s). It is well known that political intervention has in reality helped subsidize the foreign film industry, principally the American, operating in Canada. Even with hundreds of millions of dollars more invested in Canadian and Québécois cinema, we could never compete with the foreign film industry on its own turf. Nor could any other dominated culture in the world.

c) The institutionalization of our national cinema has not only created a ghost industry but is also responsible for the spending of a colossal volume

of non-productive money. Just think of the administration of all the institutions which are concerned directly or indirectly with film, as well as other related sectors: journalism, teaching, publicity, film labs and so on. And unlike the money relegated to creation and production, this volume of money is stable and protected in many cases. It decreases the political will to make our national cinema a reality and increases the uncertainties of creation and production, which remain, paradoxically, the sectors of the film industry at highest risk.

Under these conditions, creators and producers think less and less about the question of a national cinema. Or if they do, they believe it is not worth risking everything once again just to remain the eternal losers in a "business" which they themselves started without knowing how that business would evolve.

3

So where are we?

I said earlier that all creation is national because every nation is creative, inventing for itself an *imaginaire* which reflects its environment. Quebec and Québécois cinema demonstrated this fact during the sixties. Of course, the Québécois nation already existed, but cut off from the rest of the world, mired in a hierarchical religious and political nationalism. A typical quote: "I believe that a people, even if they be small in number compared to other peoples, may still fulfil the highest destiny, and be found worthy of the highest rewards, if they unite in the practice of the Catholic religion, and the love of British freedoms and Greek and French culture." (Senator Poirier, 1920, at the inauguration of the monument to Dollard des Ormeaux.)

Naturally, industrialization and urbanization slowly decreased the isolation of Quebec. But not as much, in my opinion, as the communications explosion of the fifties and the access that explosion gave the people of Quebec to new, modern tools for the making of collective and individual images. In the evolution of civilizations and nations, the tool has always played a key role; just as the Éclair camera and the portable Nagra tape

recorder, placed in the hands of neophyte Québécois filmmakers at the end of the fifties, triggered an explosion of spontaneous portraits of a society which until then had never had the chance to see itself, only others, especially the French and the American. For example, *Pour la suite du monde* could never have been made in Panavision, 35mm colour. (By the way, this film would never have seen the light of day, like the majority of Québécois films of the sixties, if, before the shooting, someone had raised the question of financial viability.)

In short, what happened is what always happens when you give new tools of creation to children: new forms of expression follow. It was also essential that those children-filmmakers had never been to school. They served their apprenticeship while shooting, while having fun—a little too much sometimes. All of these elements, along with the optimism of the times, united to allow an extraordinary osmosis between the new forms of representation of *l'imaginaire* of Quebec, and the Québécois environment from which it sprang.

I can give a concrete personal example. I did not invent the sequence shot (as others have sometimes claimed) although I use it often. It was rather the sequence shot that invented me. In 1964, during the shooting of my first feature, *Le Révolutionnaire*, it was extremely cold. The camera and the actors were freezing. What's more, we had neither the time nor the money to film conventionally with much *découpage*. What could I do? Quite simply, stand the camera and the actors around the stove, then rush them outside to shoot as quickly as possible, without cuts, before the camera and the actors could freeze once again. It was only while watching the film that I realized I had been the perfect victim, or perfect witness if you prefer, of my own environment.

This brings up another essential aspect of the concept of national cinema: that of form. As I have just suggested, form is also born of our environment. Once again, new tools aided in this birth: faster film stock and lenses, as well as better colour balance, decreased the need for make-up and the famous top light of studios. (It is because of the form of Québécois features before the sixties, a form which sought to reproduce the worst academic atrocities of French cinema, that I exclude those early features from any discussion of a Québécois national cinema. And I could say the same

about many Québécois features since the seventies. Or the majority of all English-Canadian features, I'm sorry to say.)

Besides reflecting our environment, according to the lead character in Alain Resnais's *Providence*, form "is emotion, its most direct and elegant expression." Watch again *Le Chat dans le sac* in 35mm and you will understand the precise meaning of this sentence. Think also of the majority of Québécois films which have crossed, or continue to cross, our borders: they have a specific and authentic form. (Unless the films have, on the contrary, a form so perfectly foreign or American that they appeal to our political institutions, who aid in their exportation.)

Consider as well all the filmmakers who personify the concept of national cinema: Renoir, Ford, Hawks, Buñuel (three nations), Eisenstein, Mizoguchi, Kobayashi, Bergman, Lang, Wenders, Resnais, Griffith, De Sica, Fellini . . . you will notice that not only do the stories they recount originate in their environment, but also the form through which they transmit those stories is a perfect amalgam of the specifics of that environment and the attendant emotion: the emotion of belonging to a corner of the world, a river bank, a mountain, a lake, an ocean, a season, another human being.

So we can say that the concept of national cinema is directly linked to the concept of *cinéma d'auteur*, a concept I would even apply to recent American cinema, that of Lucas, Spielberg, Coppola, Scorsese et al. The difference between Québécois national cinema and that of other nations is found in a line from Buñuel's memoir, *Mon dernier soupir:* "It is the power of a country which determines who are the great writers."

4

So what is the state of Québécois national cinema? And are Canadian national cinemas emerging? Where are we going? How will the war end between what has been already acquired, a posteriori, and what will follow, led by a political will (really more economic than political) which wants cinema to be a priori international? It's hard to say because all Canadian cinemas have to conform to an obligatory "prime time" model,[3] which in-

flicts both censorship and auto-censorship, principally on *cinéma d'auteur*, which as I have said is the backbone of any national cinema. (Excluding projects made with the help of the SGC[4] or the Canada Council, where *film d'auteur* continues: *Jacques et novembre*, *La Turlutte des années dures*, *Aerial View*, *Stations*, etc.)

It's also hard to say because for the past seven or eight years certain Canadian cinemas have been trying to affirm themselves nationally, within the framework of their environment and their reality, while at the same time they are facing an almost total centralization of standards and decision-making. (Of course, certain local TV stations or affiliates can commit to the telecast of a film, but the financial support they can provide is so small that filmmakers are obliged to go to the big centres, Toronto or Montreal, CBC or Radio-Canada, who still have all the control.)

Paradoxically, the most severely penalized are the English-Canadian cinemas which are the most dynamic: those from the Maritimes, Newfoundland and British Columbia. To truly flourish, they would need to experience a period like that of the sixties in Quebec. But this is no longer possible (including in Quebec) on any level—despite the greatly enhanced opportunities for making a film today, five hundred times greater than twenty-five years ago thanks to the many film co-ops (subsidized by the Canada Council) and the aid of the NFB and its regional offices. A real paradox, isn't it?

At the top of the pyramid of the so-called Canadian national film industry ("so-called" because it is not in the hands of Canadians), there are hundreds of millions of dollars invested each year in products which, for the most part, have nothing national about them except their time slot. At the bottom of the pyramid rest certain alternative structures, mainly the co-ops, with small financial means and in danger of stagnation. Or they strive to resemble the more dominant structures. Or, because they face the same global system of distribution and broadcasting, they try, consciously or not, to create "products" which conform to the marketplace.

We will soon have Canadian cinemas and Canadian nations united more and more not by the concept and the reality of multiple cultures, but by the concept and the reality of a national economy. But as we all know, the concept of a national economy no longer holds up: today there are

only *inter*national and *multi*national economies which create, on a global scale, only one consumer culture (as opposed to a creative culture), dominated by the "American way." It is with this consumer culture, and that obligatory prime time I have mentioned, that Canada is trying to compete. This apparently logical step is in fact a step towards annihilation, and total assimilation into the culture of the continental United States. The more Canadian films are mediocre replicas of foreign and American films, the more they are broadcast on television and the less viewers complain: what joy it is to travel all over the world and know that a Big Mac will taste the same everywhere!

So how can the concept of national cinema coexist happily with an inter- and multinational economy and the global consumer culture? Is such coexistence a utopian dream? I don't know, and in some ways I don't want to know. Our consumer culture tends to put too much trust in surveys, statistics and ratings, using them to transform policies and programs before they have had a chance to prove themselves. In any case, most of those policies do not take into account what cinema has already acquired. It was as if, at the beginning of the seventies, we blocked the natural course of the river of Québécois cinema and made it impossible to pass on that acquired experience. As if cinema no longer needed to be in the hands of filmmakers (and the producers who were risking everything) but rather in those of organizations and their non-creative, neutral, amoral, "objective" personnel!

As a consequence, we filmmakers began to divide amongst ourselves emotionally and ideologically. (And some even walled themselves in at the NFB where they could still find creative and financial security.) Some became Marxists, some capitalists, opportunists or idealists, and some have no opinions at all. There was also the war of the genres, between documentary and fiction, which is still being waged. So let's just forget about common ideas and crazy adventures. Let's only unite in the workplace and let our destiny as filmmakers rest in economic solidarity above all.

I don't think anyone has acknowledged the incredible impact of this change in the milieu of the filmmaker-creator in the seventies. Yet this change at one blow transformed the concept of national cinema, which until then was based on the collectivity of creation. A film crew was not

a hierarchy. But this situation changed, seemingly overnight. One day a technician said to me on the set: "I don't need to know *why* you're making your film, just tell me what to do and I'll do it, I'm a professional." He was right and I was wrong. I hadn't yet noticed the consequences of the internal and external changes in Quebec cinema, or that from now on I had to be the *boss* on the set (after the producer). That from now on I would have employees first and friends second.

So it was that, just when for many the hope of a rational, political affirmation of the natural Québécois nation was being born, Québécois filmmakers were experiencing their most severe crisis of solitude since the beginning of the sixties. Some took for granted that the official politicizing of the concept of nation would lead to an official endorsement of the concept of a national creation and a national cinema. Which is, officially, what occurred, but in the restricted political sense only, on the economic level. So out went our original creative cinema, or "granola cinema" as some called it, even though it was this cinema which had done so much to create a political image of Quebec for the rest of the world. Was it an imaginary image? I don't think so.

I have tried to speak of raw facts, without optimism or pessimism. As if I found myself on location, hoping that the sun would shine . . . but no, it's raining cats and dogs, and it's necessary to shoot anyway. So it is necessary to reinvent the story of the film, to make more melancholy a scene which should have been radiant. That's cinema. For me, anyway. And now rain is pouring down on Québécois and Canadian cinemas. While we try, at the cost of millions of dollars, to make the sun shine and to find each and every one a place in that artificial light.

In spite of everything, we must learn to survive in this artificiality, be it temporary or not. By creating. By trying to express our environment once again, hoping, perhaps, to transform it. Anyway, it is transforming itself . . . with or without us. Still, I prefer to believe, like Buñuel, that "somewhere between chance and mystery the imagination creeps in, the total liberty of man."

Translated by Barbara Easto

Notes

1. In French, the word *imaginaire* expresses the totality of that which is created by the imagination, including myths and legends. *L'imaginaire* is, in a sense, an amalgam of the history and the collective unconscious of a given society in a given environment.
2. I have always referred to Canadian *cinemas*, not Canadian *cinema*, to make a clear distinction between the cinemas of British Columbia, the Prairies, Ontario, the Maritimes and Newfoundland. I wrote a long article in 1989, *Les Cinémas canadiens: D'une image à l'autre* in the book published by the Cinémathèque québécoise entitled *À la recherche d'une identité: Renaissance du cinéma d'auteur canadien-anglais*.
3. At the time of writing there was a Canada-wide offensive, with substantial budgets from the federal government, to aid production of Canadian features which could be broadcast in prime time, particularly on the CBC.
4. The SGC, Société générale du cinéma, has become SODEC, la Société de développement des entreprises culturelles.

Filmography

Compiled by Robin MacDonald

L'Homoman, 1964
24 min., 16mm, b&w
Production Company: Les Films J.P. Lefebvre
Screenplay: Jean Pierre Lefebvre
Photography: Jean Pierre Lefebvre
Editing: Marguerite Duparc
Key Cast: Louis St-Pierre, Jean-Pierre Roy, André Leduc, Marie Thibault, André Poirier, Magmadbounboun

Le Révolutionnaire, 1965
72 min., 16mm, b&w
Production Company: Les Films J.P. Lefebvre
Screenplay: Jean Pierre Lefebvre
Photography: Michel Régnier
Editing: Marguerite Duparc
Key Cast: Louis St-Pierre, Louise Rasselet, Alain Chartrand, Robert Daudelin, Michel Gauthier, René Goulet, Pierre Hébert

Patricia et Jean-Baptiste, 1966
85 min., 16mm, b&w
Production Company: Les Films J.P. Lefebvre
Screenplay: Jean Pierre Lefebvre

Photography: Michel Régnier
Editing: Marguerite Duparc
Key Cast: Patricia Lacroix, Jean Pierre Lefebvre, Henri Kaden, Richard Lacroix

Mon oeil, 1966-70
87 min., 16mm, b&w and colour
Production Company: Cinak
Screenplay: Jean Pierre Lefebvre
Photography: Michel Régnier, Jacques Leduc
Editing: Marguerite Duparc
Key Cast: Raoul Duguay, Katia Bellangé, Janou Furtado, Céline Bernier, Huguette Roy, Magmadbounboun, Pauline Fortier

Il ne faut pas mourir pour ça, 1966
75 min., 35mm, b&w
Production Company: Les Films J.P. Lefebvre
Screenplay and Dialogue: Jean Pierre Lefebvre, Marcel Sabourin
Photography: Jacques Leduc
Editing: Marguerite Duparc
Key Cast: Marcel Sabourin, Monique Champagne, Suzanne Grossman,

Claudine Monfette, Gaétan Labrèche, Denise Morelle, André Pagé
Other Title: *Don't Let It Kill You*

Mon amie Pierrette, 1967
68 min., 16mm, colour
Production Company: ONF
Screenplay: Jean Pierre Lefebvre
Photography: Jacques Leduc
Editing: Marguerite Duparc
Key Cast: Francine Mathieu, Yves Marchand, Raoul Duguay, Gérard Fortier, Annie Fortier, Madeleine Thibault, Francine Thibault
Other Title: *My Friend Pierrette*

Jusqu'au coeur, 1968
93 min., 35mm, b&w and colour
Production Company: ONF
Screenplay: Jean Pierre Lefebvre
Photography: Thomas Vamos
Editing: Marguerite Duparc
Key Cast: Robert Charlebois, Claudine Monfette, Claudette Robitaille, Paul Berval, Denis Drouin, Pierre Dufresne, Luc Granger
Other Title: *Straight to the Heart*

La Chambre blanche, 1969
78 min., 35mm, b&w, 2.35:1 (Scope)
Production Company: Cinak, with the participation of the CFDC
Screenplay: Jean Pierre Lefebvre
Photography: Thomas Vamos
Editing: Marguerite Duparc
Key Cast: Michèle Magny, Marcel Sabourin
Other Title: *The House of Light*

Un succès commercial ou Q-Bec My Love ou Struggle for Love, 1969
77 min., 35mm, b&w
Production Company: Cinak

Screenplay: Jean Pierre Lefebvre
Photography: Thomas Vamos
Editing: Marguerite Duparc
Key Cast: Anne Lauriault, Denis Payne, Larry Kent, Jean-Pierre Cartier

Les Maudits Sauvages, 1971
115 min., 35mm, colour
Production Company: Cinak, with the participation of the CFDC
Screenplay: Jean Pierre Lefebvre
Photography: Jean-Claude Labrecque
Editing: Marguerite Duparc
Key Cast: Pierre Dufresne, Rachel Cailhier, Nicole Filion, Luc Granger, Jacques Thisdale, Gaétan Labrèche, Jacques Desnoyers
Other Title: *Those Damned Savages*

Ultimatum, 1971-73
126 min., 35mm, b&w and colour
Production Company: Cinak
Screenplay: Jean Pierre Lefebvre
Photography: Jacques Leduc
Editing: Marguerite Duparc
Key Cast: Francine Moran, Jean-René Ouellet, Dominique Cobello

On n'engraisse pas les cochons à l'eau claire, 1973
112 min., 16mm, b&w
Production Companies: Cinak, Prisma, with the participation of the CFDC
Screenplay: Jean Pierre Lefebvre
Photography: Guy Dufaux
Editing: Marguerite Duparc
Key Cast: Jean-René Ouellet, Louise Cuerrier, Jean-Pierre Saulnier, Marthe Nadeau, J.-Léo Gagnon, Denys Arcand, Guy Migneault, Pierre Monfils
Other Title: *Pigs Are Seldom Clean*

Les Dernières Fiançailles, 1973
91 min., 16mm, colour
Production Companies: Cinak, Prisma
Screenplay: Jean Pierre Lefebvre
Photography: Guy Dufaux
Editing: Marguerite Duparc
Key Cast: Marthe Nadeau, J.-Léo Gagnon, Marcel Sabourin
Other Title: *The Last Betrothal*

L'Amour blessé [Confidences de la nuit], 1975
77 min., 35mm, colour
Production Company: Cinak, with the participation of the CFDC
Screenplay: Jean Pierre Lefebvre
Photography: Jean-Charles Tremblay
Editing: Marguerite Duparc
Key Cast: Louise Cuerrier, with the voices of Gilles Proulx, Paule Baillargeon, Pierre Curzi, Frédérique Collin, Jean-Guy Moreau, Monique Mercure
Other Title: *Wounded Love*

Le Gars des vues, 1976
149 min., 16mm, b&w and colour
Production Company: Cinak
Photography: Yves Rivard
Editing: Marguerite Duparc
Key Cast: Claudette Chapdelaine, Roger Cantin, Alain Gendreau, Suzanne Éthier, Ivanhoe Viens, Louise Théroux

Le Vieux Pays où Rimbaud est mort, 1977
113 min., 35mm, colour
Production Companies: Cinak, Filmoblic (Paris), l'Institut national de l'audiovisuel (Paris), with the participation of the CFDC
Screenplay: Jean Pierre Lefebvre, Mireille Amiel
Photography: Guy Dufaux
Editing: Marguerite Duparc
Key Cast: Marcel Sabourin, Anouk Ferjac, Myriam Boyer, Roger Blin, Germaine Delbat, François Perrot, Mark Lesser
Other Title: *The Old Country Where Rimbaud Died*

Avoir 16 ans, 1979
125 min., 35mm, colour, 2.35:1 (Scope)
Production Company: Cinak, with the financial participation of l'Institut québécois du cinéma
Screenplay: Claude Paquette, Jean Pierre Lefebvre
Photography: Guy Dufaux
Editing: Marguerite Duparc

Les Fleurs sauvages
à Marguerite

Au rythme de mon coeur

Key Cast: Yves Benoît, Louise Choquette, Aubert Pallascio, Marthe Choquette, Lise L'Heureux, Eric Beauséjour, Alain Moffat
Other Title: *To Be Sixteen*

Les Fleurs sauvages, 1982
152 min., 16mm, b&w and colour
Production Company: Cinak, with the financial participation of the CFDC and l'Institut québécois du cinéma
Screenplay: Jean Pierre Lefebvre
Photography: Guy Dufaux
Editing: Marguerite Duparc
Key Cast: Michèle Magny, Marthe Nadeau, Pierre Curzi, Claudia Aubin, Eric Beauséjour
Other Title: *Wild Flowers*

Au rythme de mon coeur, 1983
80 min., 16mm, b&w
Production Company: Cinak, with the financial participation of the Canada Council for the Arts
Photography: Jean Pierre Lefebvre
Editing: Jean Pierre Lefebvre
Other Title: *To the Rhythm of My Heart*

Le Jour "S . . .", 1983
88 min., 16mm, colour
Production Company: Cinak, with the financial participation of l'Institut québécois du cinéma and Bellevue Pathé Québec
Screenplay: Jean Pierre Lefebvre, Barbara Easto with the participation of Marie Tifo and Pierre Curzi
Photography: Guy Dufaux
Editing: Barbara Easto
Key Cast: Pierre Curzi, Marie Tifo, Pierre Brisset de Nos, Benoît Castel, Michel Daigle, Marcel Sabourin
Other Title: *"S" As In . . .*

Laliberté, esquisse d'un homme et de son époque, 1986
84 min., 16mm, colour
Production Companies: Les Films François Brault, Les Productions Dix-Huit with the financial participation of Téléfilm Canada, la Société générale du cinéma du Québec and Radio-Canada
Screenplay: Jean Pierre Lefebvre
Photography: François Brault
Editing: Barbara Easto
Key Cast: Paul Hébert, Nicole Filion, Odette Legendre, Albert Millaire, Marcel Sabourin, Francine Ruel, Sonia Boutonnet, Laurent Celton

La Boîte à soleil, 1988
75 min., 16mm, colour
Production Company: Cinak
Photography: Lionel Simmons
Editing: Barbara Easto

Key Cast: Joseph Champagne, Barbara Easto, Simone Easto Lefebvre, Atom Egoyan, Simon Esterez, Emma Hamilton Colyer, Timothy Heyligen, Arsinée Khanjian, Jérôme Sabourin
Other Title: *The Box of Sun*

Ensemble, 1988
4 min., Video [video-clip for Richard Séguin]
Production Company: Public caméra

Sentiers secrets, 1988
4 ½ min., Video [video-clip for Richard Séguin]
Production Company: Public caméra

Laubach Literacy of Canada: The Changing Workplace, 1989
3 ½ min., Video [educational video]
Screenplay: Barbara Easto

The Laubach Solution, 1990
10 min., Video [educational video]
Screenplay: Barbara Easto

Story Time, 1990
6 min., Video [educational video]
Screenplay: Barbara Easto

Le Fabuleux Voyage de l'Ange, 1990
99 min., 35mm, colour
Production Companies: ACPAV, ONF, with the financial participation of Téléfilm Canada, SODEC and Super Écran
Screenplay: Jean Pierre Lefebvre, adapted from a scenario by Normand Desjardins
Photography: Robert Vanherweghem
Editing: Barbara Easto
Key Cast: Daniel Lavoie, Geneviève Grandbois, Marcel Sabourin, Sylvie Marie Gagnon, François Chénier
Other Title: *The Fabulous Voyage of the Angel*

Parents as Partners, 1991
9 min., Video [educational video]
Screenplay: Barbara Easto

Laubach: Training Volunteers, 1991
9 min., Video [educational video]
Screenplay: Barbara Easto

Recruiting Students for Literacy Upgrading in the Workplace, 1992
8 min., Video [educational video]
Screenplay: Barbara Easto

Atelier Altitude, 1993
20 min., Video

Il était une fois Sabrina et Manu, 1994
61 min., Video

L'Âge des images I: Le Pornolithique, 1994
51 min., Video Hi-8, b&w and colour
Production Company: Cinak
(stolen images from television)
Additional Photography: Jean Pierre Lefebvre
Editing: Jean Pierre Lefebvre

L'Âge des images II: L'Écran invisible, 1994
52 min., Video Hi-8, colour
Production Company: Cinak
Photography: Jean Pierre Lefebvre
Additional Photography: Lionel Simmons
Editing: Jean Pierre Lefebvre

L'Âge des images III: Comment filmer Dieu, 1994
52 min., Video Hi-8, b&w and colour
Production Company: Cinak
Photography: Lionel Simmons, Jean Pierre Lefebvre
Editing: Jean Pierre Lefebvre

L'Âge des images IV: Mon chien n'est pas mort, 1995
51 min., Video Hi-8, b&w and colour
Production Company: Cinak
Photography: Jean Pierre Lefebvre
Editing: Jean Pierre Lefebvre

L'Âge des images V: La Passion de l'innocence, 1995
77 min., Video Hi-8, b&w and colour
Production Company: Cinak, with the financial participation of the Canada Council for the Arts
Photography: Lionel Simmons
Editing: Barbara Easto
Key Cast: Liane Simard, Geneviève Langlois, Widemir Normil and the voice of Christophe Rapin

Aujourd'hui ou jamais, 1997
107 min., 35mm, colour
Production Company: Vent d'Est Films, with the financial participation of Téléfilm Canada, SODEC, Télé-Québec and Super Écran
Screenplay: Jean Pierre Lefebvre, Marcel Sabourin
Photography: Robert Vanherweghem
Editing: Barbara Easto
Key Cast: Marcel Sabourin, Claude Blanchard, Julie Ménard, Micheline Lanctôt, Jean-Pierre Ronfard
Other Title: *Today or Never*

H comme hasard, 1999
3 min., Video, colour [part of L'Abécédaire du 25e anniversaire du Vidéographe]

See You in Toronto, 2000
4 min., 35mm, colour
Production Company: Rhombus Media
Screenplay: Jean Pierre Lefebvre
Photography: Robert Vanherweghem
Key Cast: Marcel Sabourin

Le Manuscrit érotique
Feature film in production, 2001

Selected Bibliography

Writings by Jean Pierre Lefebvre

Books and Poems

Lefebvre, Jean Pierre. *Parfois quand je vis: Pòemes et récits.* Montréal: Hurtubise, 1971.

———. *Les Machines à effacer le temps: Mon almanach sur les média d'information.* Montréal: Scriptomédia, 1977.

———. *Sage comme une image: Essai biographique sur le cinéma et d'autres images d'ici et d'ailleurs.* Collection Cinéma. Outremont, Que.: Isabelle Hébert, 1993.

Scripts

Lefebvre, Jean Pierre. *Les Dernières Fiançailles.* Montréal: Éditions Le Cinématographe, 1977.

———. *Le Fabuleux Voyage de l'Ange.* Montréal: Libre Expression, 1991.

Articles

Lefebvre, Jean Pierre. "La crise du langage et le cinéma canadien." *Objectif,* no. 32 (April/May 1965): 27–36.

———. "10 Questions to 5 Canadian Film Makers: Jean-Pierre Lefebvre." *Cahiers du Cinema in English,* no. 4 (1966): 49.

———. "The Fuse and the Bomb." *Cahiers du Cinema in English*, no. 4 (1966): 50–51.

———. "Technique Is Absurd." In *How to Make or Not to Make a Canadian Film*, edited by André Pâquet. Montréal: La Cinémathèque canadienne, 1968.

———. "Situation du nouveau cinéma: 1. Les quatres saisons." *Cahiers du cinéma*, nos. 200–201 (April/May 1968): 108–9.

———. "Québec et la libre bêtise." *Cinéma Québec* 1, no. 1 (May 1971): 9.

———. "La cohérance dans le cinéma québécois." *Cinéma Québec* 4, nos. 9–10 (1976): 42–45.

———. "Un cinéma québécois?" *Cinéma Québec* 5, no. 1 (1977): 27–29.

———. "Cinéma Indépendant: Petite Esquisse." In *Un Cinéma sous l'influence: An anthology of the review* Lumières, *1987–1992*, edited by Jean Chabot, Isabelle Hébert, Jean-Daniel Lafond, and André Pâquet, 17–31. Montréal: Isabelle Hébert, 1988.

———. "Les Cinémas canadiens: D'une image à l'autre." In *À la recherche d'une identité: Renaissance du cinéma d'auteur canadien-anglais*, edited by Pierre Véronneau, 23–43. Montréal: Cinémathèque québécoise / Musée du cinéma, 1991.

———. "Lettre ouverte à Pierre Perrault, en guise de réflexion sur l'état de la culture et du cinéma au Québec." *24 Images*, nos. 98–99 (fall 1999): 31–33.

———. "Lettre ouverte à Michel Moreau, en guise de réflexion sur la notion de territoire." *24 Images*, nos. 103–104 (fall 2000): 30–32.

———. "Et si le cinéma québécois n'existait pas plus?" *24 Images*, no. 106 (spring 2001): 4–5.

Writings about Jean Pierre Lefebvre

Books and Articles with Interviews

Barrowclough, Susan, ed. *Jean-Pierre Lefebvre: The Quebec Connection.* BFI Dossier Number 13. London: British Film Institute, 1981.

Beaulieu, Janick. "Jean Pierre Lefebvre." In *Le Cinéma québécois: Par ceux qui le font*, edited by Léo Bonneville, 546–79. Montréal: Éditions Pauline, 1979.

Harcourt, Peter. *Jean Pierre Lefebvre.* Ottawa: Canadian Film Institute, 1981.

Jean Pierre Lefebvre: Rétrospective—novembre 1973. Montréal: Cinémathèque québécoise, 1973.

Samuels, Barbara. "Jean-Pierre Lefebvre: Flowers to Cannes." *Cinema Canada*, no. 84 (May 1982): 23–24.

Books and Articles

Bérubé, Renald, and Yvan Patry, eds. *Jean-Pierre Lefebvre*. Montréal: Les Presses de l'Université du Québec, 1971.

Chabot, Jean. "Jean-Pierre Lefebvre." In *Second Wave*, edited by Ian Cameron, 124–27. Translated by Elizabeth Kingsley-Rowe. New York: Praeger, 1970.

Euvrard, Michel, and Yves Rousseau. "Lefebvre, Jean Pierre." In *Le Dictionnaire du cinéma québécois*, edited by Michel Coulombe and Marcel Jean, 393–97. Montréal: Boréal, 1999.

Fraser, Graham. "The Gentle Revolutionary," *Take One* 1, no. 7 (October 1967): 10–13.

Harcourt, Peter. "Jean Pierre Lefebvre: A Second Glance." In *Images: Festival of Independent Film and Video*, 29–39. Toronto: Images: Festival of Independent Film and Video, 1991.

La Rochelle, Réal, and Gilbert Maggi. "Political Situation of Quebec Cinema," *Cinéaste* 5, no. 3 (summer 1972): 2–9.

Larsen, André. "Le sens de la contestation et Jean-Pierre Lefebvre." In *Le Cinéma québécois: Tendances et prolongements*, edited by Renald Bérubé and Yvan Patry, 49–53. Montréal: Les Éditions Sainte-Marie, 1968.

Lever, Yves. "*Chambre blanche*." In *Cinéma et société québécoise*, 126–30. Montréal: Éditions du jour, 1972.

———. "*Q-Bec My Love ou Un succès commercial*." In *Cinéma et société québécoise*, 134–41. Montréal: Éditions du jour, 1972.

Marshall, Bill. "Auteurism after 1970." In *Quebec National Cinema*, 133–71. Montreal and Kingston: McGill-Queen's University Press, 2001.

Notar, Clea H. "Lefebvre, Jean Pierre." In *International Dictionary of Films and Filmmakers*, 3rd ed., vol. 2, *Directors*, edited by Laurie Collier Hillstrom, 584–85. Detroit: St. James Press, 1997.

Rasselet, Christian. *Cinéastes du Québec 3: Jean-Pierre Lefebvre*. Montréal: Conseil québécois pour la diffusion du cinéma, 1970.

Acknowledgements

I would like to thank Piers Handling for inviting me to present the Canadian Retrospective entitled "Jean Pierre Lefebvre: Vidéaste" at the 2001 Toronto International Film Festival and for commissioning this book to accompany the programme. I would also like to acknowledge the generous support for this publication provided by the Canada Council for the Arts.

I am grateful to Sylvie Marois who, at an early stage, assisted me with the French dialogue of the videos of Jean Pierre Lefebvre: Steve Gravestock for his organization of the retrospective; Robin MacDonald for her tireless and exacting work on the filmography and the film and video stills; Gordon Robertson for his fine sense of book design; and Doris Cowan and especially Catherine Yolles for their scrupulous editing of the text.

I would also like to thank Barbara Easto for her translations of the texts and Robert Gray for his English subtitles of the videos. Finally, I thank Jean Pierre Lefebvre for, throughout the years, his poems, articles, books, videos and films—and for his friendship.

Peter Harcourt

Text Sources

The extract from the poem "La Fleur Carnivore" is from *Parfois quand je vis: Poèmes et récits* (1971) by Jean Pierre Lefebvre. The English translation by Barbara Easto is as follows:

> The secrets one keeps to oneself
> are neither secrets nor poems,
> they are traces of childhood.
>
> They must die. One must speak them,
> the same way the mouth, so close to
> the heart and scarcely aware of moving,
> imposes them on a wounded hand—
> perhaps a severed one.
>
> Since that day, however,
> I have understood that
> to remain faithful to Time
> would be my suicide.

The quotations throughout the essay "The Music of Light" are from the articles by and interviews with Jean Pierre Lefebvre listed in the bibliography. Their sources are identifiable by date.

"Snapshots from Quebec" first appeared in *Essays on Quebec Cinema*, Joseph Donohoe, editor, published by Michigan State University Press, 1991.

"The Concept of National Cinema" was originally published as "Le concept de cinéma national" in *Dialogue: Cinéma canadien et québécois / Dialogue: Canadian and Quebec Cinema*, Mediatexte Publications Inc. and La Cinémathèque Québécoise, Pierre Véronneau, Michael Dorland, Seth Feldman, editors, 1987. English translation copyright © Barbara Easto 2001.

Illustration Sources

The drawings that appear throughout the text are by Jean Pierre Lefebvre.

Film stills are courtesy of The Film Reference Library, Toronto and La Cinémathèque québécoise. Video stills were prepared by Peter Harcourt.

Title page photograph of Jean Pierre Lefebvre is courtesy of Viliam/Rhombus Media.